IMAGES
of America

NORTHWEST DENVER

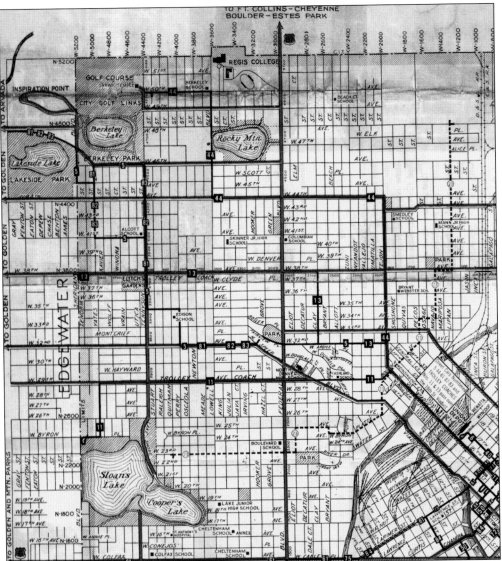

NORTHWEST DENVER, C. 1940. This map gives an idea of the geographic area covered in this book (excluding the lower right portion). It shows the streetcar lines (bold lines with numbers in blocks) that would, by 1950, be converted to bus routes. Note the absence of the I-25 and I-70 freeways, which, to great controversy, sliced through the city in 1958 and 1966 respectively. (Author's collection.)

ON THE COVER: THE BUNGALOW, C. 1910. After her first husband, John, died, Mary Elitch became known as "The Lady of the Gardens," the only female proprietor of an amusement park in the United States. After John Mulvihill bought Elitch Gardens in 1916, he allowed Mary to continue living in this home within the park, which she did until 1932. (Denver Public Library, Louis Charles McClure, MCC-1238.)

IMAGES
of America

NORTHWEST DENVER

Mark A. Barnhouse

ARCADIA
PUBLISHING

Published by Arcadia Publishing
Charleston, South Carolina

Printed in the United States of America

Library of Congress Control Number: 2011931703

For all general information, please contact Arcadia Publishing:
Telephone 843-853-2070
Fax 843-853-0044
E-mail sales@arcadiapublishing.com
For customer service and orders:
Toll-Free 1-888-313-2665

Visit us on the Internet at www.arcadiapublishing.com

*To the memory of my grandmother, Stella F. Kaelin
(1894–1993), who lived in northwest Denver for a time.
Also to Charlie (2000?–2011), a dog who knew
the streets of West Highland well.*

CONTENTS

Acknowledgments

Several individuals have contributed advice, photographs, or both, and I must thank Margaret Buerkle; Dana EchoHawk; Dennis Gallagher; Shannon Garcia; Rev. Hugh M. Guentner, OSM; Dick Kreck; Leslie Krupa; Ellis McFadden; Jim McNally; James A. Maestas; Ann Maestas; Dave Ricciardi; JoAnn Seaman; Gene Smaldone; Matt Wallington; and Mike Wilzoch. Special thanks go to Dr. Thomas J. Noel for his encouraging words. I must also thank Kenton Forrest of the Colorado Railroad Museum and Sarah Everhart of History Colorado. At the Denver Public Library Western History Collection, thanks to Wendell Cox, Coi Drummond-Gehrig, Bruce Hansen, James K. Jeffrey, and Jim Kroll. At Arcadia Publishing, I thank editors Stacia Bannerman, Simone Monet-Williams, and Debbie Seracini.

The images in this volume appear courtesy of the Colorado Historical Society (CHS), the Colorado Railroad Museum (CRM), the Denver Public Library Western History Collection (DPL), *Denver Municipal Facts* (DMF; this abbreviation also covers periods when the city's publication was known as *City of Denver* and *Municipal Facts*), Our Lady of Mount Carmel Church (OLMC), the author's own collection, and various organizations and private individuals as noted. Early street names were inconsistent—therefore, I have mostly used modern names, which were standardized between 1897 and 1904.

INTRODUCTION

Northwest Denver covers a broad swath of the Mile High City, north of West Colfax Avenue and west of the South Platte River and Union Pacific railroad yards. In recent years, it has become popular to refer to this side of the city as the "Brooklyn of Denver," perhaps referring not only to the way that residents of other parts of the city have suddenly "discovered" it after decades of not paying it much attention, but also to the area's rich diversity—both geographic and cultural. Like Brooklyn, northwest Denver has historically been home to immigrant communities and a variety of religious faiths. Like Brooklyn, Denverites have long come to the northwest side to partake of its recreational amenities and amusement resorts. And like Brooklyn, northwest Denver has struggled with issues of gentrification. But it's not fair to either Brooklyn or northwest Denver to make this comparison, because each place is unique unto itself.

Northwest Denver's roots date to 1858, the year Denver itself was founded, when city father Gen. William Larimer platted some streets west of the river and named the new town "Highland." Denver City and Auraria, rival towns facing each other across Cherry Creek, merged into one city in 1860; Highland was included, but its name shifted in general usage to "North Denver." Separated from Denver and Auraria by the river and steep bluffs, Highland was initially slow to develop, although a bridge at the present-day location of Fifteenth Street was built as early as 1860.

Proximity to the central part of the city made the land too valuable to remain empty, especially after the arrival of the railroads in 1870. Various businessmen bought North Denver acreage and platted developments, including Stephen D. Kasserman, Hiram Witter, and Daniel T. Casement. The Independent Order of Odd Fellows bought land for a cemetery in 1866 (they sold it a decade later), and—acting for the American Baptist Missionary Union of Boston, Massachusetts—the Rev. Walter M. Potter of Denver's First Baptist Church purchased 320 acres (including today's Potter Highlands Historic District) for development in 1873. In the 1880s, prominent Denver businessmen such as Nathaniel P. Hill and George Tritch also developed sections of northwest Denver.

Gen. William Jackson Palmer, the wealthy founder of the Denver & Rio Grande Railroad, together with Dr. William A. Bell, bought 364 acres just west of Gallup Street (now called Zuni Street) in 1870; at the time, this street marked Denver's western city limits. Palmer and Bell organized the Highland Park Company, platting their land in the "picturesque" style that was popular in the second half of the 19th century in reaction to the then-dominant pattern of 90-degree-angle gridiron streets. Highland Park was laid out with curving streets that followed topographical contours and were graced with evocative Scottish names, such as Dunkeld, Caithness, Argyle, and Clyde. Palmer and Bell hoped to attract wealthy residents, but the area's isolation worked against them; they eventually abandoned plans for additional curving streets extending west to Lowell Boulevard and north to West Thirty-eighth Avenue. However, Highland Park became the core of the town of Highlands, which incorporated in 1875 and enjoyed an independent existence until 1896, when its citizens voted to be annexed by Denver. At its full extent, Highlands' borders ranged from Zuni Street to Sheridan Boulevard and from Colfax Avenue to West Thirty-eighth Avenue.

By the 1890s, "The Boulevard" (now known as Federal Boulevard), a tree-lined route thought suitable for mansions, was what boosters hoped would become the most impressive street in Highlands. Daniel Witter, a relative of the aforementioned Hiram, and Joseph B. Cofield were early landowners west of the Boulevard. They bought property between West Twentieth and Twenty-sixth Avenues and laid out a subdivision in 1875. Development took off after 1882, when Biddle Reeves, a Philadelphian who had come to Colorado for his health, formed the Boulevard Highlands Improvement Company. Although it never quite rivaled the "Millionaire's Row" of Capitol Hill, the Witter-Cofield Historic District is still home to a number of interesting Victorian houses in the Queen Anne style.

One man employed by the Highland Park Company became an important developer in his own right: John Brisben Walker, who partnered with Bell in another venture northwest of Highlands. Walker, "who never ran out of ways to make money," according to historian Ruth Eloise Wiberg, had purchased land on the high ridge above Clear Creek for $1,000 in 1879. He and Bell formed the Berkeley Farm and Cattle Company in 1885 to raise alfalfa; after further purchases, the team had nearly 1,700 acres under cultivation. Bell and Walker sold Berkeley Farm to a Kansas City real estate syndicate in 1888. Walker's yield was $325,000, which he used for various ventures, including the purchase of a magazine—Cosmopolitan—that he later sold to William Randolph Hearst. Residents living on Walker's land eventually incorporated as the Town of North Denver, with a Town Hall (demolished in 2010) at West Forty-fifth Avenue and Yates Street. Since the name "North Denver" was being confused with the Denver neighborhood east of Zuni Street, "Berkeley" was chosen instead, recalling Berkeley Springs, Virginia, where Walker had once lived. Berkeley was annexed to Denver when the city and county of Denver formed in December 1902; residents were not consulted.

Perhaps because every city has one quadrant predominantly favored by the wealthy—in Denver, these neighborhoods were south and east of downtown—the 20th century saw northwest Denver's initially middle-class, temperance-favoring, suburban citizenry evolve into something far more heterogenous. Beginning in the late 19th century, the area on either side of West Colfax Avenue attracted Eastern European Jews, who established a bustling neighborhood. At the same time, Italian immigrants began moving into North Denver from "the Bottoms," an early neighborhood in the Platte River floodplain. North Denver became the city's vibrant "Little Italy." After World War II, as second- and third-generation Italian Americans began moving to the suburbs, their homes began to be filled with Latino families. People of Spanish or Mexican descent, whether recent immigrants or established in Colorado and New Mexico since the days of Spanish land grants, flocked to Denver for the same reason the Italians had come: job opportunities. By 1980, northwest Denver was majority-Hispanic. Most recently, the area has started yet another transformation, with an influx of college-educated young families (mostly non-Latino) displacing—to some extent—earlier groups, but adding yet more tiles to the northwest Denver mosaic. Remnants of every group that has ever lived in northwest Denver, and many of their institutions, remain in the area today, making it one of the city's most interesting and diverse places to live.

One

TRANSPORTATION AND COMMERCE

The physical form of northwest Denver, as we know it today, is a legacy of early rail transportation. The horsecar (arrived in 1873), the cable car (1889), and the electric streetcar or trolley (also 1889) greatly lessened the distance between the northwest side and other parts of town. In particular, the streetcar, the mode of transportation that "won" against the others, wove the various sections of Denver into a whole. Moreover, the trolley broadened people's horizons; according to historian Kenneth T. Jackson (*Crabgrass Frontier*, 1985), "the public took advantage of the mobility it offered to explore other neighborhoods that had previously been as foreign to them as another land." Streetcars also helped to create a series of business districts along their routes—although these strips declined after the 1950 demise of streetcars, they have recently returned to life with new uses that again draw people from other parts of town.

Viaducts across the many railroad tracks and the South Platte River were nearly as important as the streetcar in stitching the northwest side onto the rest of the city. From south to north, they were the Colfax Avenue, Fourteenth Street, Sixteenth Street, Twentieth Street, and Twenty-third Street viaducts (a Fifteenth Street viaduct was added after World War II). The West Thirty-eighth Avenue "subway" dealt with the tracks by diving under them. Funding for each project came from different sources—cable car and streetcar companies, railroads, or the taxpaying citizens of Denver. All viaducts were replaced with new ones, or with surface streets, in the 1980s and 1990s.

The freeway, the primary transportation innovation of the mid-20th century, had both positive and negative aspects. Like streetcars and viaducts, freeways connected northwest Denver with other parts of the city and metropolitan area. However, the ill-conceived routing of Interstates 25 and 70 had the pernicious effect of cutting neighborhoods in half, ruining two major parks, destroying property values, and harming human health. Beginning in 1958, area residents fought against the West Forty-eighth Avenue alignment of what would become Interstate 70, proposing the use of West Fifty-second Avenue (the city's northern boundary) instead, but ultimately lost the battle.

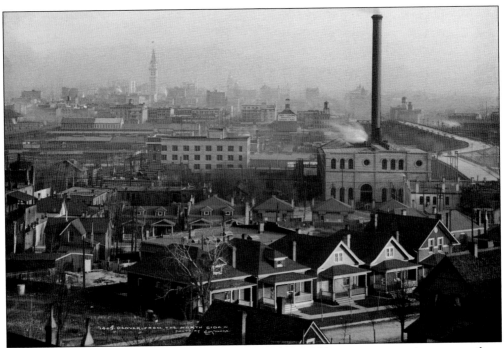

DTC Powerhouse, 1911 (above) and 1901 (below). In 1899, various competing street railway companies, whether cable or electric streetcar, were consolidated into the Denver City Tramway Company (later known as Denver Tramway Corporation). The new entity, controlled by financier William Gray Evans, soon converted cable systems to electric streetcars and built a centrally located, 100,000-kilowatt powerhouse on the South Platte River at its confluence with Cherry Creek. By 1903, it was being fed coal from the company's own mine at Leyden, west of Arvada. In the foreground of the above image, streets are lined with houses, many of which were removed in the 1950s for construction of the Valley Highway (a.k.a. Interstate 25); the Fourteenth Street viaduct is visible at right. (Above, DPL, MCC-1409; below, CRM.)

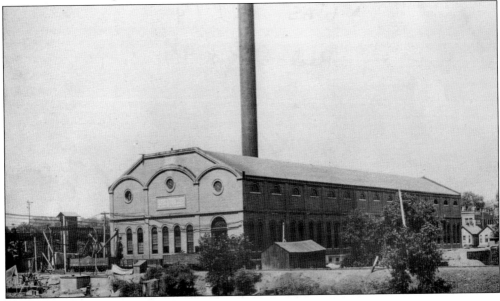

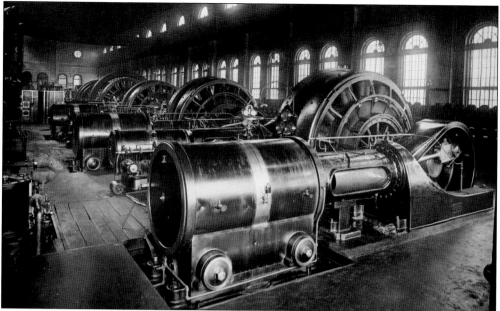

DTC POWERHOUSE, 1916. Powerhouse designer Stearns-Roger Company created drama on the exterior with Romanesque detailing and in the interior through repeated arched windows and a 42-foot ceiling. The 19 boilers were works of industrial art. The powerhouse ceased operations in 1950, after a coal strike and the end of streetcar service. In 1968, J. Donovan Forney bought the building and opened a transportation museum in the vast space and on the land surrounding it—he assembled a collection of over 300 vehicles, including large train engines. The Forney Museum of Transportation has since relocated, and the powerhouse building currently houses a 90,000-square-foot outdoor goods store; this recent development might have surprised the serious-faced powerhouse workers pictured below. (Both, CRM.)

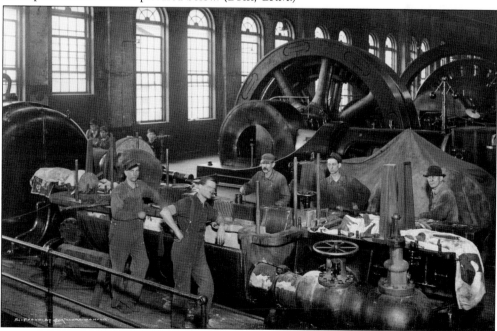

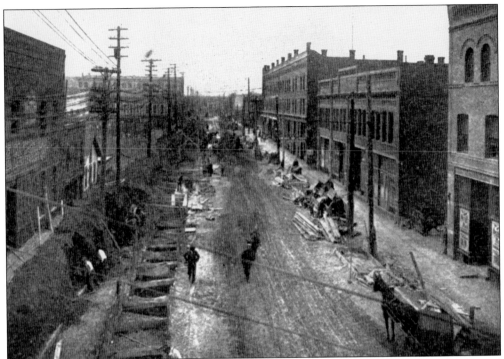

PLATTE STREET, 1911. As viewed from the Sixteenth Street viaduct, three redbrick industrial buildings, all still standing, dominate the northwest (right) side of Platte Street in the Highland business district. In the background is the three-story Eddy Block, built by brewer Adolph Zang. Next, the two-story Liberty Hall, built in 1889–1890, housed the Big Chief Bottling Company. The foreground edifice was built by cigar merchant Amos H. Root in 1890. (*DMF.*)

UPPER FIFTEENTH STREET, 1983. Fifteenth Street between Central and Boulder Streets was home to a number of offbeat businesses in the 1970s and 1980s, including the legendary Muddy Waters of the Platte coffeehouse; fire later destroyed several buildings. Earlier tenants of these edifices and those facing them included the North Denver Bank, the Tabor Volunteer Hose Company, and various shops. (DPL, Z-10485.)

WHEELER BLOCK, 1920. Just west of upper Fifteenth Street, at West Twenty-ninth Avenue and Vallejo Street, railroad man Charles E. Wheeler built this brick block in 1890, extending the Highland business district's more urban character into a residential area. Unusually, it was an apartment building that also housed various fraternal organizations. Today, it is an office building. (DPL, X-25168.)

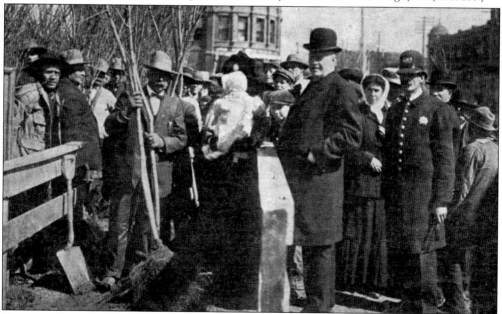

TREE DISTRIBUTION, 1911. Mayor Robert W. Speer (center) presided over the city's annual tree giveaway at West Dunkeld Place and Zuni Street. This was one of three "stations" where maples and elms were given to residents. According to *Denver Municipal Facts*, "demand was greatest at the North Side station, shade not being as plentiful over that way as in some other sections." (DMF.)

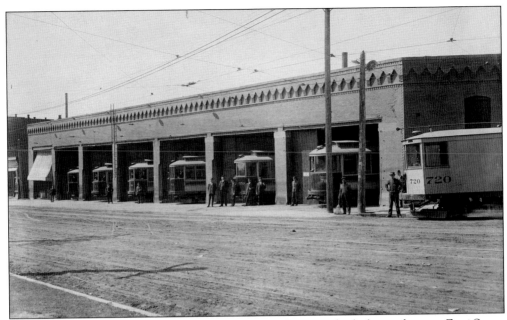

NORTH DIVISION CAR BARN, 1911. Denver Tramway Company built this car barn on Zuni Street and West Caithness Place around 1891, anchoring the northwestern end of its Fifteenth Street cable line; it housed streetcars at the time of this photograph. It was demolished after 1950 and a shopping center was built in its place; in 2011, a residential development replaced the shopping center. (DPL, MCC-4198.)

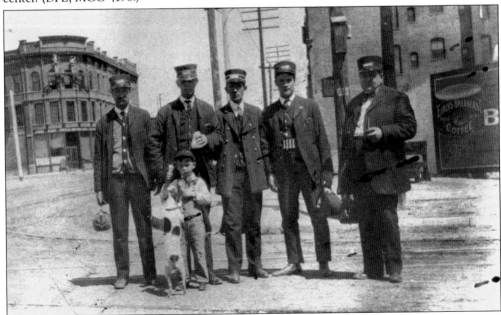

OCHILTREE BLOCK, 1905. Tramway workers identified as, from left to right, Ditson, Rowe, Hardy, Cleaver, and Colitini pose on Zuni Street with a boy and his dog. The three-story Ochiltree Block (left background) at the corner of Zuni and West Dunkeld Place was designed by Wenzel J. Janisch and J. Edwin Miller and built in 1892 by Scottish immigrant Hugh Ochiltree for the North Side Savings Bank (which later became Central Bank and Trust). (CRM.)

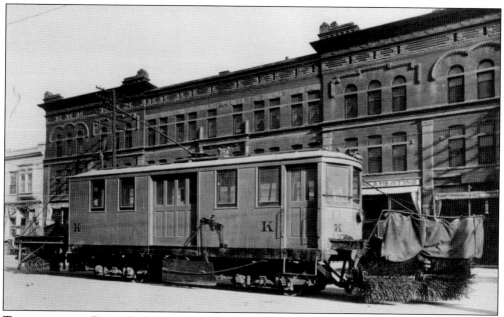

TALLMADGE AND BOYER BLOCK, 1920. Tramway track sweeper "K" stands on Zuni Street. Behind it, the Charles Tallmadge and John Boyer Block was built by north Denver realtors in 1891 after being designed by Wenzel Janisch and Edwin Miller. Positioned to capture pedestrian traffic disembarking from streetcars, it housed a dry goods store, a grocery, the *Highland Chief* newspaper (1890–1940s), and apartments. (CRM.)

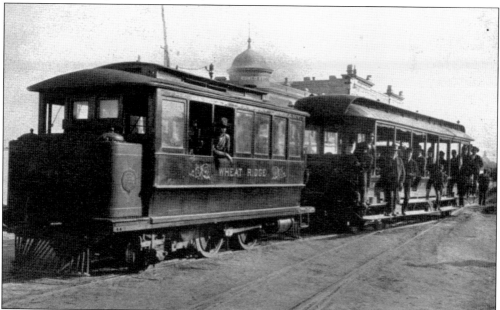

JITNEY TRAM, 1891. Denver Tramway ran this steam dummy engine with open-air trailer to Elitch Gardens; it was later converted to run on electric power. The Romeo and Tallmadge and Boyer buildings on Zuni Street are visible behind the tram. The Romeo Building, designed by Vigo and Harold Baerrensen, was on the "wet" side of the Denver-Highlands border and originally housed a liquor store. (Author's collection.)

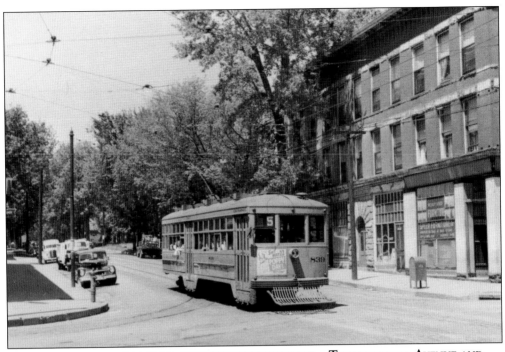

THIRTY-SECOND AVENUE AND ZUNI STREET, 1949. Anchoring the Zuni Street commercial strip (West Twenty-ninth to West Thirty-second Avenues), the Weir Building is visible at right. Built by Gilbert R. Weir around 1887 or 1889, its four stories have housed offices and shops (including the early Highland Garden movie theater), as well as the Weir Hall ballroom on the top floor. (CRM.)

EGYPTIAN THEATER, C. 1926. Neighborhood physician Dr. Herman Maul developed the "Egyptian Maul" at West Thirty-second Avenue and Clay Street. A mixed-use building, it was anchored by the obelisk-marked Egyptian Theater, the Allen Studio of Dance, Skaggs Grocery, and the SeCheverell-Moore Pharmacy, with apartments upstairs. The Egyptian became the Holiday Theater in the 1950s and closed in the 1980s. (DPL, X-24645.)

THIRTY-SECOND AVENUE AND CLAY STREET, C. 1952. SeCheverell-Moore Pharmacy still occupied the Maul property after World War II. The buildings visible at right were later demolished for an expansion of the North High School campus. Electric coaches replaced streetcars on this No. 13 line in 1940; diesel buses replaced the streetcars in 1955. (CRM.)

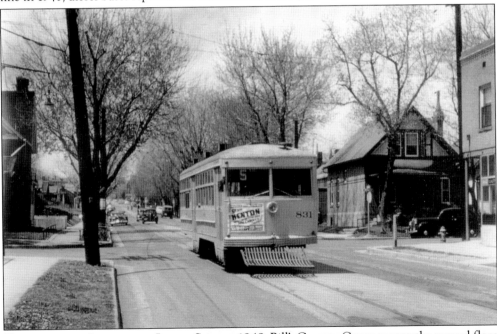

THIRTY-SECOND AVENUE AND IRVING STREET, 1949. Bill's Grocery Creamery was the ground-floor tenant of the building at far right when this photograph was taken of the No. 5 streetcar heading east on Thirty-second Avenue. Emmaus Lutheran School was, and is, on the opposite side of the avenue. The Denver Bread Company now occupies the Bill's Grocery Creamery space. (CRM.)

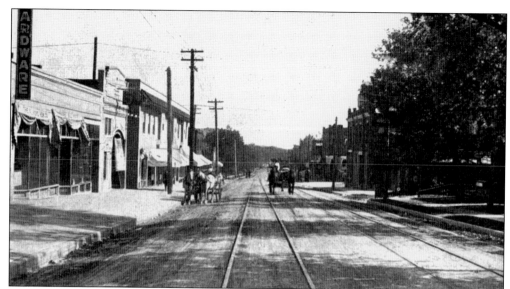

Thirty-second Avenue and Lowell Boulevard, 1913 (above) and 1915 (below). One of the larger streetcar commercial strips grew up on West Thirty-second Avenue in a two-block stretch centered on Lowell Boulevard. Above, looking east from Meade Street, the Edison Theater (with arched entry) is next to the hardware store. Also on the left, just past the light two-story building with the awnings, is a dark two-story building that housed a cinema called the Highland and, in the 1930s and 1940s, a J.C. Penney. Below, the light two-story building (which still stands) was home to several shops—the Hicks Dry Goods space later housed the Highland Pharmacy. The Denver police used the small booth at right to hold suspects before transporting them to the station. (Above, *DMF*; below, DPL, MCC-4300.)

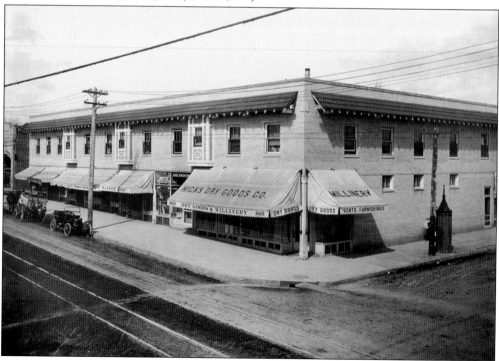

THIRTY-SECOND AVENUE AND LOWELL BOULEVARD, 1950 (ABOVE) AND 1949 (BELOW). Denver citizens rushed to take photographs of the disappearing streetcar in 1950. Above, car No. 831 discharges a passenger; the two-story building at right, Homer Hall, still anchors this southeast corner. By this time, nearby Beth Eden Baptist Church had bought the two-story building on the northeast corner; the edifice eventually was torn down to make room for a strip center with parking. Just beyond, the church built Eden Manor, a 12-story residence for seniors, in 1962. Below, the Tramway's coal train, running from the mine at Leyden, was a common sight until 1950. In the 1980s and 1990s, the Thirty-second Avenue district began to attract new entrepreneurs drawn by its charm. (Right, Margaret Buerkle; below, CRM.)

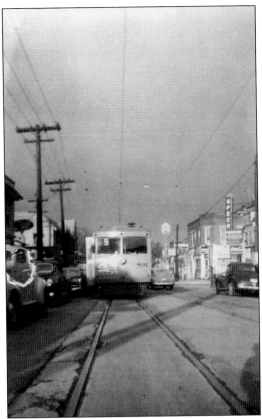

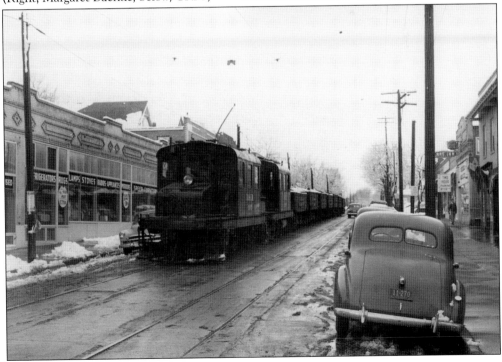

19

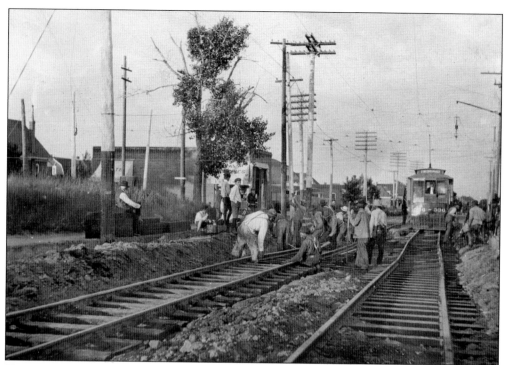

Thirty-eighth Avenue and Lowell Boulevard, 1905. West Thirty-eighth Avenue, widened to four lanes in the late 1950s, is clearly meant for automobile traffic in the present day, but in the early 20th century, the streetcar was the dominant form of wheeled transportation. These men work swiftly to replace earlier, lighter rails with heavier ones. The one-story commercial building at left remains standing today. (CRM.)

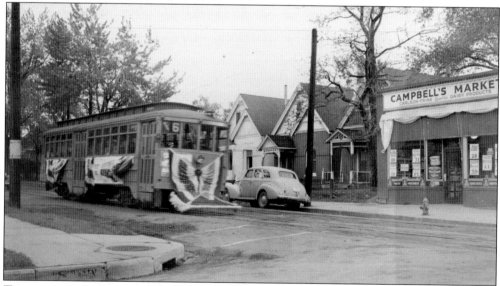

Thirty-third Avenue and Perry Street, 1950. Festooned with bunting, a streetcar makes a final northbound run on Perry Street. Campbell's Market served residents as well as students attending the nearby Edison School. Markets of this diminutive size were located on many northwest Denver corners. This building is now a residence. (CRM.)

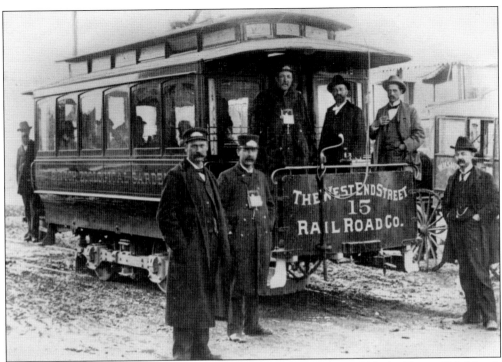

WEST END STREET RAILROAD, 1890 (ABOVE) AND 1904 (BELOW). In 1890, the Town of Highlands gave the West End Street Railroad permission to lay electric streetcar lines to the Manhattan Beach and Elitch Gardens amusement parks. The company built a large car barn and powerhouse just north of West Thirty-eighth Avenue, between Tennyson and Utica Streets, to serve its network. In the photograph below, taken on Utica Street, the Alcott School, located at Tennyson Street and West Forty-first Avenue, is visible in the distance. After consolidation with Denver Tramway Company, its subsidiary, the Leyden Coal Company, operated a retail coal yard next to the car barn; the building was eventually converted to an armory. In 1952, after the armory was demolished, the Elitch Lanes bowling alley opened in its place. (Both, CRM.)

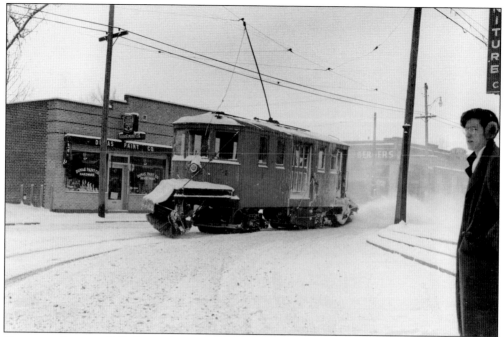

TENNYSON STREET, 1948 (ABOVE) AND 1950 (BELOW). The longest streetcar-spawned commercial strip in northwest Denver was on Tennyson Street between West Thirty-eighth and West Forty-fourth Avenues. Due to its distance from downtown, it functioned as "Main Street" for the Berkeley neighborhood and was home to various shops and services, including a silent-era cinema. The clothing store Eaker's grew into a large Colorado chain from its Tennyson Street base. Above, track sweeper No. 4 heads southbound at West Forty-first Avenue, while below, car No .05 of the Denver & Intermountain Railway (another Tramway subsidiary) passes Alcott Pharmacy. Lincoln Wilson owned the pharmacy; his son Don was comedian Jack Benny's "straight man" for three decades. (Above, DPL, X-27858; below, CRM.)

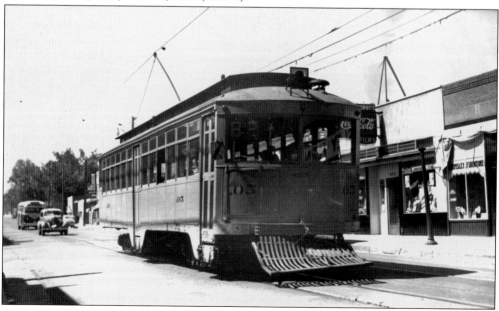

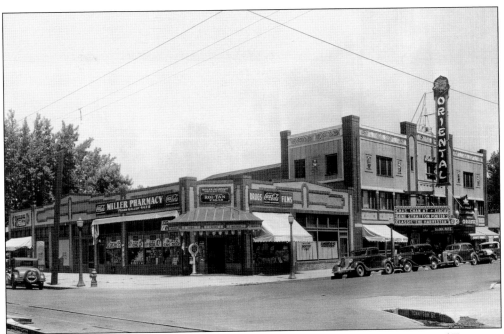

ORIENTAL THEATER, 1936. Opened in 1927 on West Forty-fourth Avenue, just east of Tennyson Street, the Oriental was a typical small cinema, utilizing an exotic theme and "bank night" contests to entice customers to stay in the neighborhood rather than going downtown. Note the miniature pagoda and Buddha on the original marquee. (DPL, X-24690.)

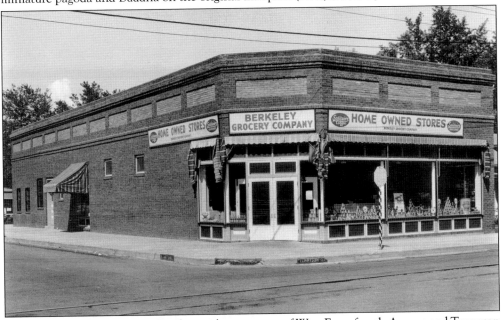

BERKELEY GROCERY, C. 1920. On the northwest corner of West Forty-fourth Avenue and Tennyson Street, the Berkeley Grocery was a larger grocery operation than Campbell's Market (page 20). Utilizing Denver's Morey Mercantile Company ("Solitaire," visible on the signage, was Morey's brand name) as its wholesaler, Berkeley Grocery operated for several decades. In recent years, Simone Parisi and his wife, Christine, have operated a popular Italian eatery and market in this space. (DPL, X-24190.)

SAVE-A-NICKEL NUMBER ONE, 1940. Save-A-Nickel, located at 4210 Tennyson Street, was operated by L.W. "Lud" Rettig. He partnered with Californian Lloyd J. King, who arrived in Denver in 1934 with $700 to invest. They opened more stores; King sold his share to Rettig in 1944. After the war, King returned and founded the King Soopers chain. (DPL, X-24073.)

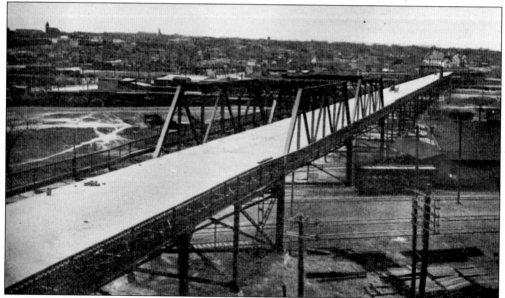

TWENTIETH STREET VIADUCT, 1911. Most early viaducts were built for streetcars, with other traffic a secondary consideration. A harbinger of the future, the Twentieth Street viaduct was the first built to exclude streetcars in favor of automobiles. Its northwestern terminus was St. Patrick's Church (far right, at end of viaduct). Fr. Joseph Carrigan (page 83) agitated for the viaduct; Mayor Robert Speer strong-armed the railroads into paying most of its cost. (*DMF.*)

FORTY-FOURTH AVENUE, 1913. A long row of cottonwood trees made West Forty-fourth Avenue between Lowell Boulevard and Tennyson Street into a verdant tunnel, perfect for pleasure drives to Berkeley Park. The trees were removed in the 1930s, partly by poor families who needed firewood; the city paid to have the rest cut down. (*DMF.*)

MURPHY-MAHONEY CHEVROLET, c. 1935. In the 1920s, automobile dealers began clustering on major thoroughfares. In northwest Denver, they favored the zone where Federal and Speer Boulevards intersected. Hover Ford had a prime spot at that junction, while Murphy-Mahoney Chevrolet, at 2986 Speer Boulevard, stood opposite North High School. (CHS, Mazzulla Collection, 20007841.)

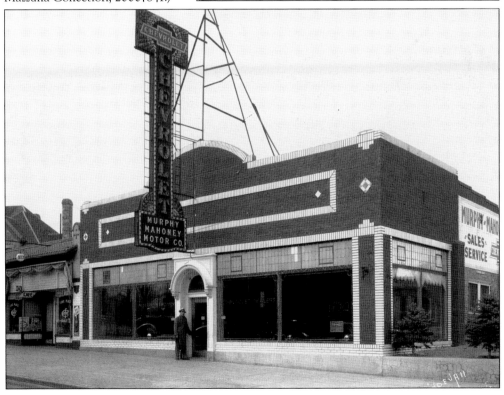

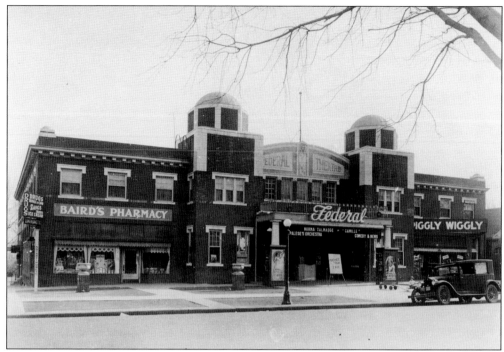

FEDERAL THEATRE, 1927. Twin domes lend grandeur to the still-standing Federal Theatre, built in 1923 just north of West Thirty-eighth Avenue on Federal Boulevard. Baird's Pharmacy, at left, featured Zang's Ice Cream, one of the products made by the northwest Denver brewer during Prohibition. Spratt's Market, at right, owned a franchise of a then-rapidly growing national chain called Piggly Wiggly. (DPL, X24675.)

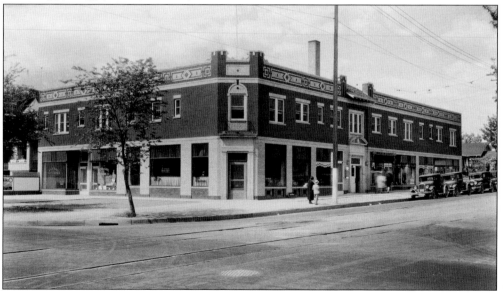

COLUMBUS APARTMENTS, C. 1928. The two-story apartment block with ground floor retail space is common in east and south Denver, but less so in the northwest. Its developer, likely Nix Realty occupying the ground floor corner at West Thirty-eighth Avenue and Federal Boulevard, made full use of the site along two busy automobile thoroughfares. (DPL, MCC-3754.)

Two

SUBURBS

In *History of Denver* (1902), Jerome C. Smiley opined that streetcars "are to a great degree responsible for the absence from the city of anything approaching a 'tenement house district.'" He also recognized that "[t]hese adequate means of transportation in every direction have enabled men to build their castles where trees and grass and flowers may grow." Such was the suburban ideal that inspired early northwest Denver settlers.

This ideal could not be realized in arid Colorado without water. At the Highlands Town Hall dedication in 1890, Roger W. Woodbury claimed that when he had arrived in 1866, "there was not a bleaker spot in the territory of Colorado" than what would become Highlands. Soon, Hiram Wolff helped dig the Highland Ditch (later merged into the Rocky Mountain Ditch), and natural lakes were enlarged for storage. In 1886, Frank P. Arbuckle took advantage of the area's artesian wells to form the Beaver Brook Water Company.

Water was available, but in another sense, Highlands was entirely dry. In pre-Prohibition years, a saloonkeeper could legally set up a business, but only after paying an exorbitant $5,000 annual fee for the privilege. No one did so, but saloons sprang up across the borders in wet Denver and Edgewater to slake the thirst of Highlanders who did not support temperance.

Pure water and morals gave rise to a sense of superiority over Denver. In 1890, the *Rocky Mountain News* described Highlands as a city of "nearly 8,000 inhabitants, who look down from their happy homes upon the eminence from where she grandly sits upon the smoky city below at eventide, with her 'gloomy splendour red,' and thank the stars that they do not dwell among the smelter and factory smoke." Mayor George F. Lewis boasted that "[we] are proud of Highlands, for we have better water, better streets and more intelligent people, more capable city governors than any other city in this broad state. The people of Denver would be only too glad to live in Highlands. They are coming."

DENVER, C. 1872. The "great braggart city" (in English traveler Isabella Bird's words) spreads below the nearly empty rise that would become the independent town of Highlands. "The cactus, soap root, lizard and rattlesnake have held undisputed sway in this hot parched sand for ages past . . . but water is everything, and money, with labor and science, can accomplish almost anything," according to an 1874 newspaper report. (DPL, X-19445.)

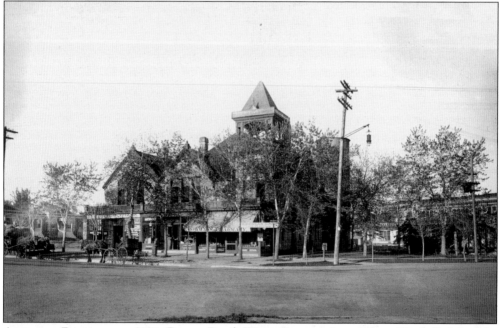

ARBUCKLE BUILDING, C. 1911. Beaver Brook Water Company's president, Frank P. Arbuckle, discovered that water was relatively abundant, as artesian wells dotted the district. He took over this building at Speer and Federal Boulevards, originally built by the Highland Park Company around 1884, and used it as his headquarters. The building also served as the second Highlands Town Hall; it burned down after World War II. (DPL, X-24840.)

Town Hall, 1890. Highlands Town Hall, at West Twenty-sixth Avenue and Federal Boulevard, was purpose-built in 1890. Designed by Highlander William Quayle, it included a jail, a fire station, and a post office. At its dedication, Denver mayor Wolfe Londoner became annoyed with Highlands mayor George F. Lewis's bragging of Highlands' superiority and promised that the city would never thrive without annexation to Denver. (*Rocky Mountain News.*)

St. Luke's Hospital, c. 1885. The Grand View House hotel opened in 1873 at the Denver City Railway's North Denver terminus at West Seventeenth Avenue and Federal Boulevard. Despite grand views, business was lacking, and it closed by 1877. In 1881, St. Luke's Hospital moved in, but relocated to east Denver 10 years later when doctors complained about having to cross railroad tracks. (DPL, X-28689.)

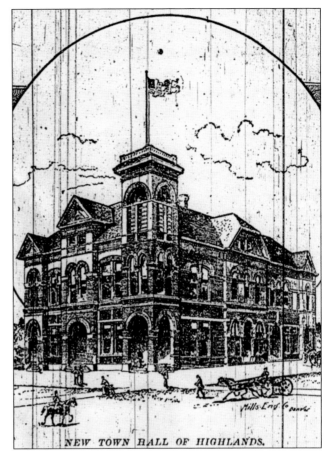

NEW TOWN HALL OF HIGHLANDS.

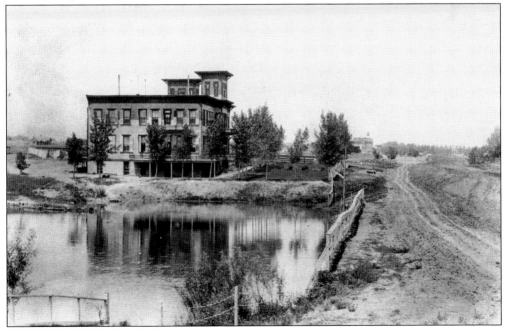

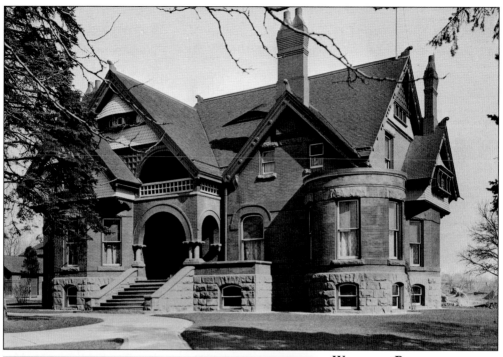

WOODBURY RESIDENCE, C. 1930 (ABOVE) AND 1948 (LEFT). Civil War veteran Roger Williams Woodbury came to Denver in 1866, and became involved in mining, publishing (the Denver *Tribune* and *Times*), streetcars, banking, and agriculture. He was elected to the legislature, the University of Colorado Board of Regents, and the presidency of the Denver Chamber of Commerce; he also proposed the nickname "Centennial State" for Colorado. He built an impressive mansion on the northwest side, on a now-demapped street called Woodbury Court (between Zuni and Alcott Streets) and West Twenty-fifth Avenue. Financially ruined in the Panic of 1893, Woodbury died in 1903. The house was demolished in 1966; today, the Diamond Hill office complex occupies the site. (Above, DPL, X-27123; Left, X-27131.)

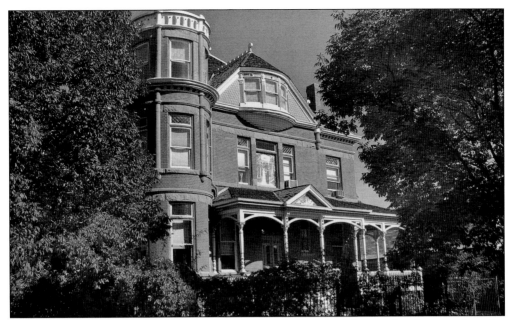

MOUAT RESIDENCE, 2010. In 1890, wealthy lumber dealer John Mouat, who also served as vice president of North Side Building and Loan, built this 8,500-square-foot home at West Thirty-seventh Avenue and Bryant Street. Later subdivided into 23 apartments (and the scene of an infamous 1970 double murder), the building was saved from demolition and renovated to become the Lumber Baron Inn. (Author's collection.)

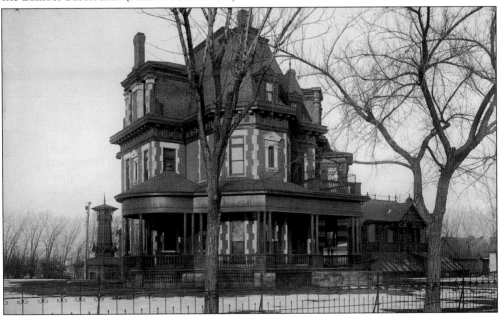

POMEROY'S FOLLY, C. 1900. Marcus "Brick" Pomeroy, a Confederate sympathizer, spiritualist, newspaper man, charmer of ladies, and swindler, created 25 mining companies that never paid investors. He built this brick mansion at West Thirty-seventh Avenue and Federal Boulevard in 1880 and lost it in the Panic of 1893. It was demolished in 1935 after serving for several years as the Belle Lennox Home for Young Children. (DPL, C-171.)

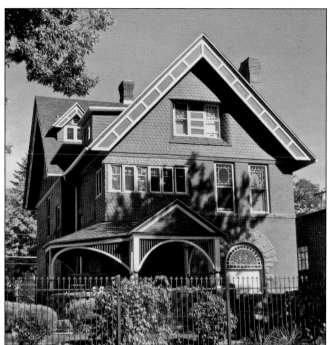

LEE RESIDENCE, 2010. Henry Lee came to Colorado in 1865 and eventually built a seed and farm implement business at Sixteenth and Wazee Streets in downtown Denver. Lee worked with Jacob Downing to establish Denver's park system in the 1880s and built this mansion at West Thirty-second Avenue and Clay Street in 1894–1895, the worst part of the depression that followed the Panic of 1893. (Author's collection.)

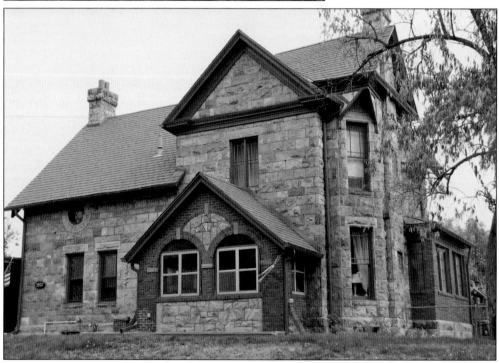

WALKER RESIDENCE, 2010. In 1885, Bolivar Walker, John Brisben Walker's brother, commissioned stonemason David Cox (whose "Gargoyle House" stands at nearby 3425 Lowell Boulevard) to design a home at 3520 Newton Street. The property was originally larger, with a driveway extending from Lowell Boulevard. Unusually, the house is stone with brick trim rather than the other way around. (Author's collection.)

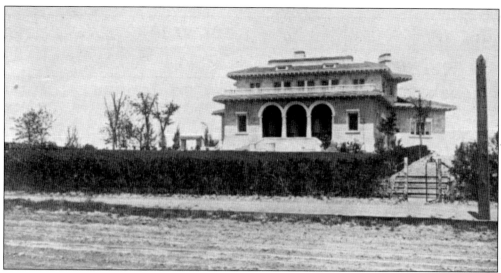

McDonough Residence, 1910. Harkness Heights (Federal to Lowell Boulevards, West Forty-first to Forty-fourth Avenues) would become the "North Side's Capitol Hill," as John McDonough assured buyers; he built his home on West Forty-sixth Avenue and Perry Street. McDonough promoted June 25, 1910, as "North Side Day," a celebration of "that spirit which has reclaimed an expanse of moor and fen and made it into a district fair to behold." (*DMF.*)

Wimbush Residence, c. 1890. John McDonough and Carleton Ellis undertook development of Berkeley following its sale by John Brisben Walker. They commissioned William Lang, Denver's foremost residential architect, to create a series of homes scattered around the district. One of the finest was this one, which still stands at West Forty-ninth Avenue and Stuart Street. (DPL, X-19032.)

WOLFF RESIDENCE, 2010. Hiram G. Wolff helped dig Highland Ditch in 1862, bringing water to Highlands from distant Golden. With his Sunnyside Nursery nearby, he built this home at West Thirtieth Avenue and Newton Street in 1891. He sold it to the Mullen Home (page 62), and when that institution eventually sold it, the deed was written to ensure that a large family would always occupy it. (Author's collection.)

CARTER RESIDENCE, 1912. This mansion at 2959 Perry Street was built in 1912 by Florida lumberman William Carter, who developed the three blocks from Perry to Tennyson Streets, between West Twenty-ninth and Thirtieth Avenues. Carter also sold automobiles, holding franchises for the Overland and the Apperson "Jack Rabbit," both now largely forgotten manufacturers. (*DMF.*)

HEISER RESIDENCE, 2005.
German immigrant
Herman Hugo Heiser
came to Denver in 1874
by way of Blackhawk
and Central City. He
established a saddlemaking
business famous for bespoke
saddles built to customers'
dimensions. His brother-
in-law, Matthew Wolter,
designed and built this 1893
mansion at West Thirtieth
Avenue and Osceola Street,
complete with a third-floor
ballroom and an "HHH"
monogram on the front
porch. (Author's collection.)

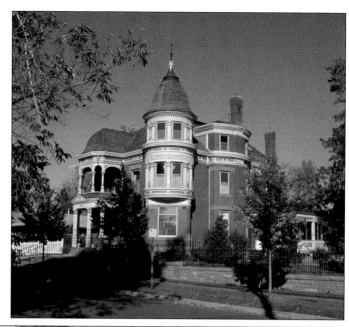

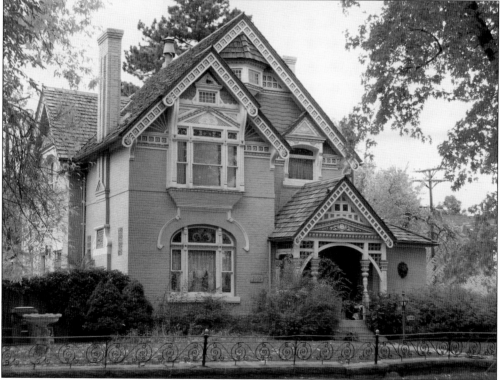

NEEF RESIDENCE, 2010. A jewel of the Witter-Cofield Historic District, this 1886 Queen Anne–style home was built at 2143 Grove Street by German immigrant Frederick Neef. He arrived in Denver in 1873 and bought a brewery in partnership with his brother Maximillian (renamed, naturally, Neef Brothers Brewing Company) in 1892. Their popular beer sold well, but the advent of Prohibition destroyed their business. (Author's collection.)

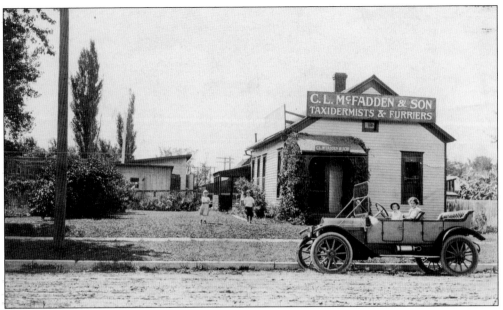

McFadden Family, 1910 (above) and 1907 (below). The Charles Lorraine McFadden (1873–1962) family personified the middle-class character of neighborhoods that bordered Federal Boulevard. McFadden, who operated a taxidermy/curio business at various downtown locations, married Leila Bryant, daughter of attorney Andrew Jackson Bryant, in 1905. The couple moved into her family's home at 2149 Federal Boulevard, which had an outbuilding (above) behind the house that was suitable for the business. By 1910, the family could afford an automobile. Despite the "& Son" on the sign, neither son, Bryant nor Weldon, would join the business. The family's living quarters (below) were likely typical of others in the Witter-Cofield subdivision, with older Victorian elements mixed with newer Arts and Crafts items. (Both, Ellis McFadden.)

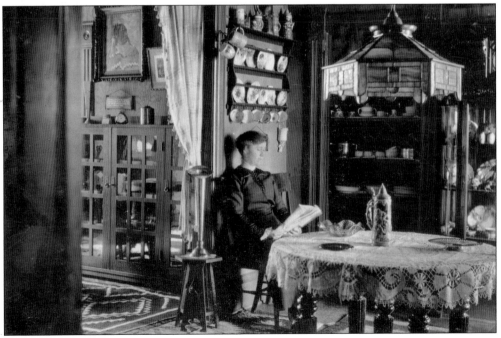

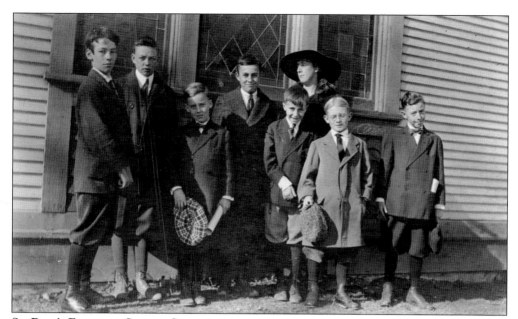

St. Paul's Episcopal Sunday School, 1917. Bryant McFadden, at far right, stands with other members of his Sunday school class. He likely attended this Sunday school because it was located one block from home, at the southwest corner of West Twenty-third Avenue and Federal Boulevard. His parents considered themselves Presbyterian. This wood-frame church was built in 1889 and demolished in 1925. (Ellis McFadden.)

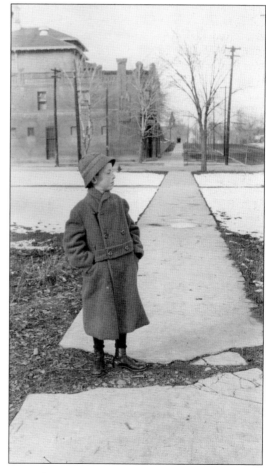

Bryant McFadden, 1912. Six-year-old Bryant McFadden stands on Federal Boulevard, near West Twenty-third Avenue. Behind him are a commercial building and Boulevard School (both still standing); in the distance, the steeple of the since-demolished Boulevard Congregational Church is visible. Bryant's son Ellis remembers that this corner used to be home to a Piggly Wiggly grocery and a drugstore with a marble-topped soda fountain. (Ellis McFadden.)

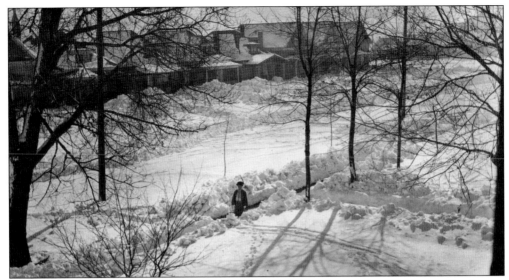

BLIZZARD AFTERMATH, 1913. A McFadden, either Bryant or his brother Weldon, walks down a cleared Federal Boulevard sidewalk after the blizzard of December 4, 1913. In later life, Bryant (1906–1984) worked for American Can and Colorado National Bank. Weldon (1907–2005) was a World War II photographer who later moved to Southern California and landed a job with Technicolor, Inc. (Ellis McFadden.)

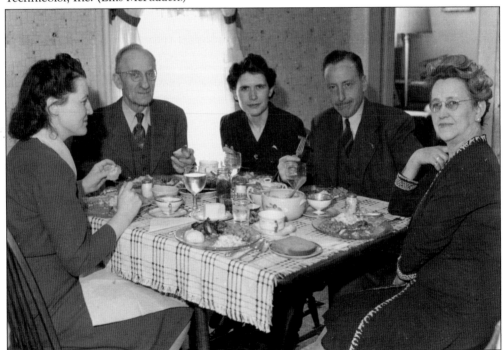

McFADDEN FAMILY, 1944. Pictured here are, from left to right, Ellen (Weldon's wife), Charles L., Shirley (Bryant's wife), Bryant, and Leila McFadden. The family had moved to Hays, Kansas, during the 1920s, and returned to Colorado after 1930. With the children gone and the poor economy, the McFaddens divided the house into several apartments, keeping one for themselves. The house has since been converted to office space. (Ellis McFadden.)

Three

NORTH SIDE CULTURES

Not long after the suburb of northwest Denver had established a predominantly middle-class and Anglo-Saxon Protestant character, people of different ethnicities began flocking to the area as well. Proximity to downtown and the developing industrial zones along the South Platte River, along with convenient transportation links, were major attractions; that streets were filled with both small, working-class houses, and sizeable homes suitable for large families, increased the likelihood that the area would become more diverse.

The first new groups to establish roots in northwest Denver, often after time spent working in Colorado's mining camps, were German, Irish, Welsh, and Cornish immigrants (and second-generation Americans). Unlike later groups, these (largely) English speakers did not cluster into ethnic enclaves, but instead felt free to live anywhere else in the city when their needs drew them out of northwest Denver. Russian and Polish Orthodox Jews, on the other hand, preferred to live close to other members of their faith, concentrating along West Colfax Avenue.

Italian immigrants were drawn to an area centered on Navajo, Osage, and Pecos Streets. North Denver became dotted with Italian churches, grocers, fraternal lodges, shops, schools, and food manufacturers. The air was filled with the scent of bread baking in outdoor dome ovens. Banding together in a community helped the Italians to alleviate the isolation of living far from home and to combat outsiders' anti-Italian prejudices.

After World War II, later generations of Italian Americans began drifting to the suburbs; Latinos largely replaced them. Northwest Denver's Latino population grew from 13 percent in 1950 to 21 percent in 1960, 45 percent in 1970, 60 percent in 1980, and nearly 69 percent in 1990. Tensions were inevitable—longtime residents grew increasingly uncomfortable at changes happening around them, and the Latino community had to fight for political rights and social justice. This chapter includes the stories of two families, one Italian and one Latino, to illustrate the experiences of these groups beyond the histories of their institutions and prominent individuals.

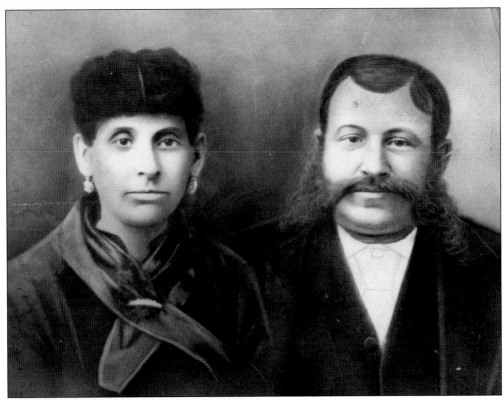

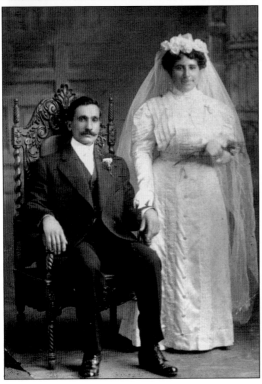

THE LO SASSOS, 1878 (ABOVE), AND THE RICCIARDIS, 1909 (LEFT). When Filomina Lo Sasso died in 1933 at the age of 88, she was mourned by 66 survivors. Born in 1846, she and her husband Gerardo (Americanized to Jerry) migrated from Potenza, Italy, to Denver in 1878 after landing in New York in 1873. At first settling in the Bottoms along the South Platte River, they later moved to north Denver near West Thirty-fourth Avenue and Osage Street. In 1893, Filomina gave birth to Carolina, one of 20 children (10 of whom did not survive into adulthood). In 1909, Carolina married Nunzio Ricciardi, and the couple (left) settled into a house near West Thirty-second Avenue and Navajo Street. Nunzio, then 30 years old, had emigrated from Messina, Sicily. (Both, Ricciardi family.)

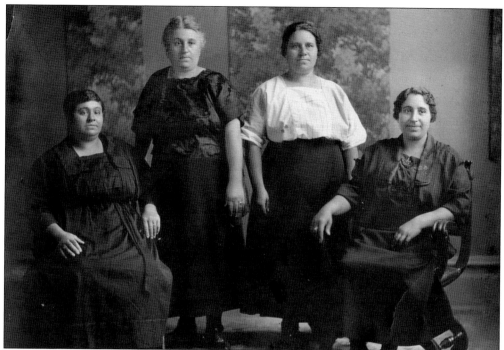

FOUR LO SASSO SISTERS, 1932 (ABOVE), AND RICCIARDI FAMILY, 1932 (BELOW). In 1932, four surviving daughters of Filomina and Gerardo Lo Sasso posed for a portrait. They are, from left to right, Anna ("Annie") Giordano, Antoinette ("Nettie") Trollo, Josephine Figliolino, and Carolina Ricciardi. That same year, Carolina and Nunzio Ricciardi (below, seated in front) posed with their six living children. They are, from left to right, Julius (whose twin, Edith, died at age two), Carmela, Josephine, Anthony, Florence, and Eugene. Josephine married into the Vagnino family, co-owners of the American Beauty Macaroni Company. Its factory was located at 2428 Nineteenth Street (an address erased by the construction of Interstate 25), and it grew to become one of the largest macaroni producers in the United States. (Both, Ricciardi family.)

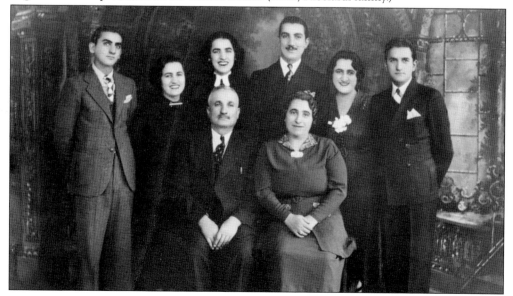

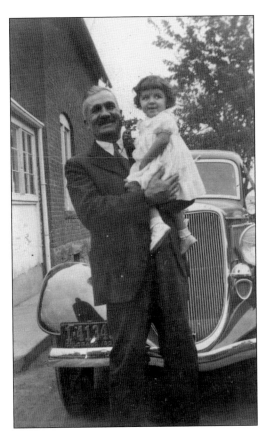

NUNZIO RICCIARDI AND FAMILY, 1934 (LEFT) AND 1941 (BELOW). Nunzio was a proud grandfather during the christening of Mary Louise Zarlengo (left), who was born in 1933 to his daughter Florence and Henry C. Zarlengo. Mary Louise grew up to focus her life on education, becoming the first female principal in Adams County schools. Passionate about teaching, she won many awards and national recognition. Below, Nunzio poses with his sons Eugene (left) and Antonio (center) in front of the Schermerhorn Cottage on West Thirty-third Avenue. This Oakes Home satellite (page 58) was next door to the Ricciardi family home, and after the Oakes Home leased it to the Unicorn Tea Room, Eugene worked there before joining the military. (Both, Ricciardi family.)

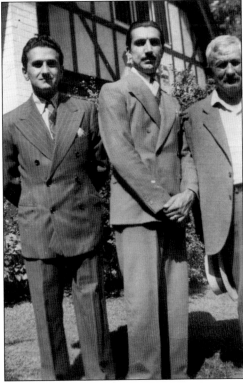

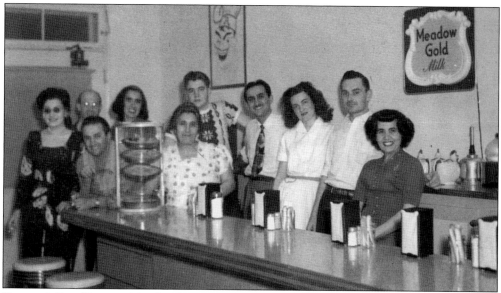

RICARDI'S FINE FOODS, 1948. In 1942, Nunzio's youngest son, Julius, decided to open a restaurant. With an Americanized name, "Ricardi's" (the name "drove Grandfather Nunzio crazy," according to one family member) was located at 4325 West Forty-first Avenue, just east of Tennyson Street, and was in business until 1955. Open from 12:00 p.m. to 10:00 p.m. seven days a week, in addition to homemade spaghetti and ravioli, the menu featured "delicious southern pan fried chicken" and "choice Grade A corn fed steaks." Above, behind the counter are, from left to right, unidentified, Earl Harrington, Eugene Ricciardi, Josephine Vagnino, Carolina Ricciardi, unidentified, Julius Ricciardi, Kathryn Ricciardi (Julius's wife), unidentified, and Carmela Ricciardi Gerstner. Below, Julius poses in front of the restaurant. (Both, Ricciardi family.)

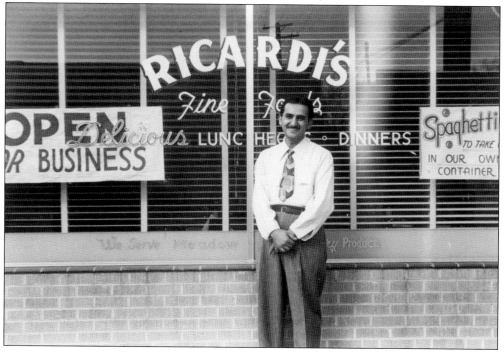

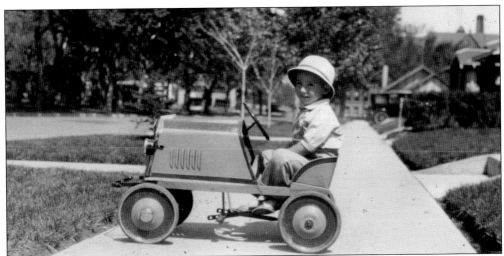

Gene Smaldone, 1933 (above), and Smaldone Family, c. 1978 (below). Gene Smaldone was three years old when he drove the pedal car (above) in front of his family's home on West Forty-first Avenue near Grove Street. His parents, Clyde and Mildred Smaldone, made sure he had a normal childhood despite family ventures in bootlegging and illegal gambling. Gene never followed in his well-known father's or uncles' footsteps, instead becoming a high school football coach and entrepreneur. Below, Clyde and Mildred (seated) enjoy the company of their sons, Chuck (left) and Gene at a birthday dinner for Mildred at Gaetano's, the longtime hub of the family's business activities. By this time, Clyde had foresworn crime, cultivating a quieter life. He was generous, according to his sons, and often brought orphans home for Christmas. (Both, Gene Smaldone.)

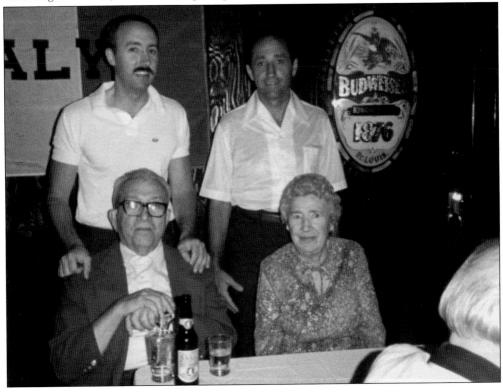

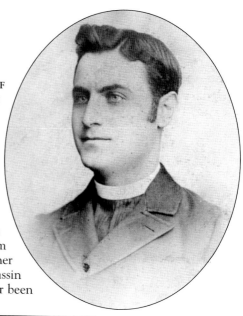

FATHER LEPORE, C. 1903 (RIGHT), AND OUR LADY OF MOUNT CARMEL CHURCH, 1931 (BELOW). Mount Carmel Church, at West Thirty-sixth Avenue and Navajo Street, has been the heart of Denver's Italian community for more than a century. Established specifically for Italians in 1894 by Fr. Joseph P. Carrigan of St. Patrick's Church, Mount Carmel was led by Fr. Mariano Lepore. After fire destroyed the original wooden building in 1898, Lepore worked to build a new church on the same site. Amid allegations that he used donated funds improperly, about 500 parishioners split off to form a separate congregation. In November 1903, Father Lepore was shot while in his study; he and his assassin died the following day, and the motive has never been fully understood. (Both, OLMC.)

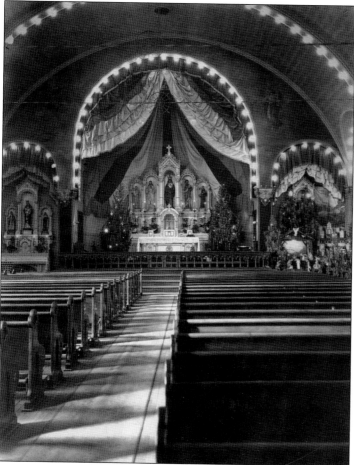

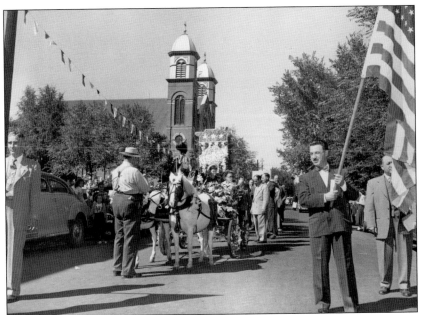

MOUNT CARMEL FESTIVALS, C. 1948. Mount Carmel's longest-running tradition, the Feast of St. Rocco, is held every August. It celebrates the French saint Roch, or Rocco. Many of Denver's early Italian immigrants migrated from Potenza, Italy, and running the annual feast has been, since 1926, the work of the Società Nativi di Potenza Basilicata (Potenza Lodge). The St. Rocco statue came from Potenza in the 1890s and resides in the church. The lodge holds an auction, and the winning bidder is accorded the right to carry the statue aloft as it makes its way along a several-block parade route. In the 1950s, it was common for several thousand people to view the parade, including top politicians. Although turnout is lower today, the celebration remains enthusiastic. (Above, OLMC, Jerry Acierno/Ingle Portraits; below, author's collection.)

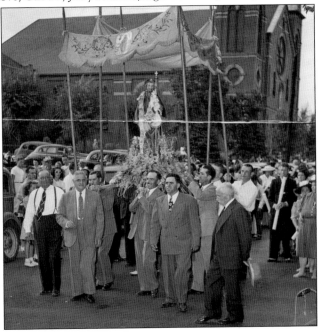

MOTHER CABRINI (RIGHT) AND QUEEN OF HEAVEN ORPHANAGE, C. 1917 (BELOW). Mother Frances Xavier Cabrini came to the United States in 1889 to better the lives of Italian immigrants. In 1902, at the invitation of Bishop Nicholas Matz and Fr. Mariano Lepore, she came to Denver to establish a school. She soon turned her attention to the plight of orphaned girls, buying a farmhouse and land at West Forty-eighth Avenue and Federal Boulevard in 1905 for an orphanage (below). By 1917, a larger building was necessary, so the sisters commissioned John James Huddart to design a replacement. Mother Cabrini died that year; she was canonized in 1946 as the patron saint of immigrants and orphans. In 1962, the orphanage accepted a planeload of Cuban girls fleeing Fidel Castro's revolution. The Queen of Heaven Orphanage closed in 1967. (Right, Mother Cabrini Shrine; below, DPL.)

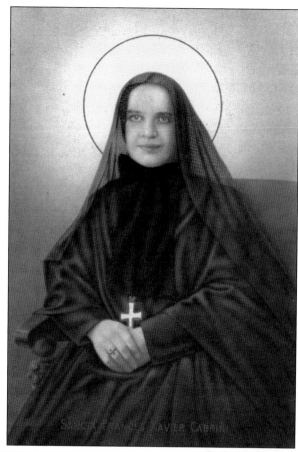

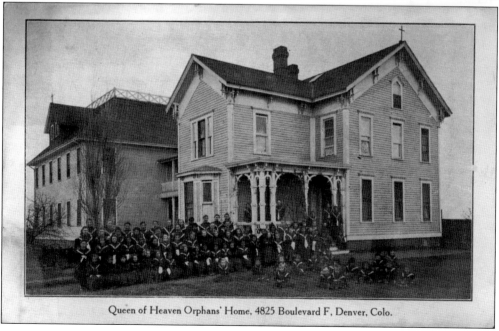

Queen of Heaven Orphans' Home, 4825 Boulevard F, Denver, Colo.

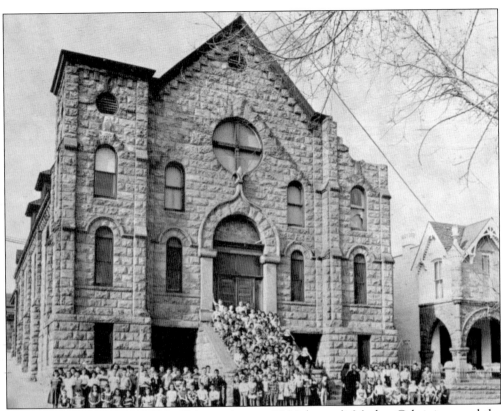

MOUNT CARMEL SCHOOL, C. 1945 (ABOVE), AND 1964 (BELOW). Mother Cabrini opened the Mount Carmel School at 3357 Navajo Street, the home of Michele "Michael" Notary. In 1908, the school moved into the building above, the San Rocco Chapel, which was constructed in 1900 by builder/architect Frank Damascio at West Thirty-sixth Avenue and Osage Street, one block from the Mount Carmel Church and next door to his house (visible at right in the above image). Damascio built it for parishioners who left Father Lepore's Mount Carmel Church, but, lacking the blessing of Bishop Matz, the chapel never joined the diocese. For a time, the congregation flirted with becoming Greek Orthodox. The school built a new building in 1955, and closed in 1968. The second-grade "Beatles" shown below were among the school's last students. (Both, OLMC.)

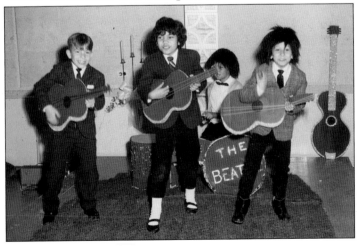

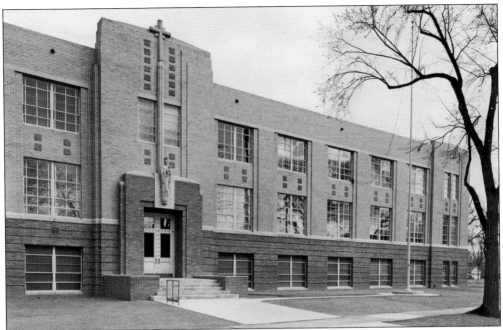

Mount Carmel High School, c. 1952. After World War II, Mount Carmel built separate buildings for the primary and high schools. The latter, on Zuni Street and West Thirty-sixth Avenue, was dedicated in 1951; the faculty included Sister Mary Ellen (below), who was not above having fun. Father Tom LoCascio was the driving force behind the new facilities; Clyde Smaldone, then at the peak of his influence in the community, spearheaded a fundraising drive that yielded $50,000 toward construction. The high school, along with the replacement primary school at West Thirty-sixth Avenue and Pecos Street, closed in 1968. The high school was demolished, and the site is currently home to the Academia Ana Marie Sandoval, a dual-language Montessori school. (Above, DPL, X-28251; below, OLMC.)

49

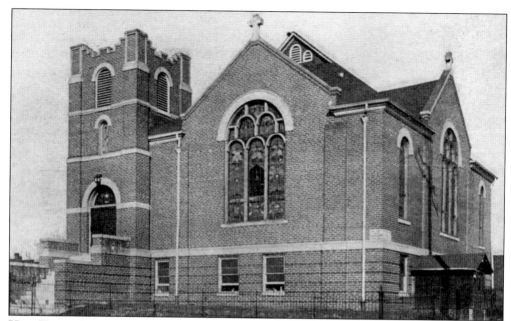

Holy Trinity Italian Evangelical Church, 1914. Seeking to woo Italians away from Catholicism, north Denver Protestants established a mission that eventually occupied this church at West Thirty-sixth Avenue and Lipan Street. Headed by the controversial Rev. Francesco P. Sulmonetti, the church provided a night school, home economics instruction, and lunches for children. The largely Catholic Italian community did not always appreciate the church's outreach efforts. (*DMF.*)

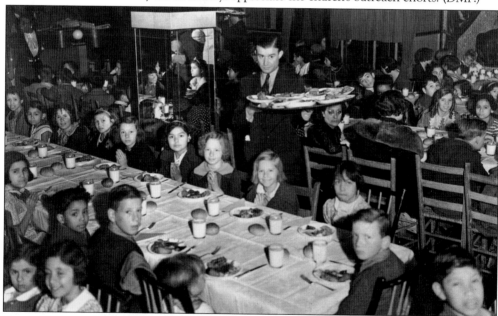

Tivoli Terrace, 1936. The *Denver Post* printed this photograph to publicize its association with a Thanksgiving dinner for needy children given by Tivoli Terrace proprietors Hyman Hirshorn and T. Romolo. This multiethnic crowd reflected the changing demographics of the north side. The nightclub was located in an old firehouse at 1900 West Thirty-second Avenue, a building that has since been converted to apartments. Hirshorn's name lives on at a nearby park. (DPL, X-23249.)

READERS, 1951. A newspaper photographer found Gilbert Vigil (left) and Phil Ortega, of 3256 Wyandot Street, in front of Woodbury Library in Highland Park. By the early postwar period, northwest Denver was rapidly changing as Italian Americans moved out and Latino families moved in, attracted by the area's relatively central location and reasonable housing prices. (DPL, X-25152.)

EXHIBITION BOXING, C. 1943. James Maestas was born in Denver in 1934; his grandfather, Facundo Maestas, had arrived with his family in 1923 from Ocaté, New Mexico. During World War II, James (the boy at right, facing away from the camera) and other boys traveled to Lowry Army Air Force Base in east Denver for an exhibition match for the entertainment of the airmen stationed there. (James and Ann Maestas.)

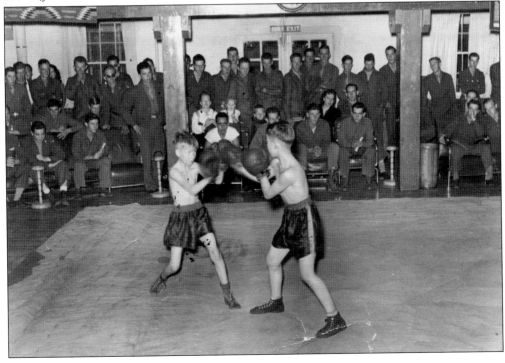

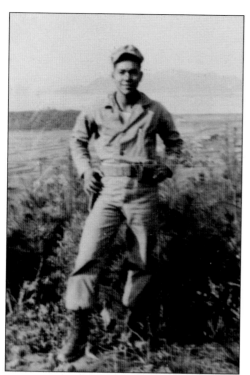

Tour of Duty, 1953. At 18, James Maestas joined the Marines and was sent to Korea during the last months of the Korean War; he remained in the corps until 1954. He later became active in veterans' affairs, joining the Mile Hi Chapter of the American G.I. Forum and eventually serving as chapter chairman and Colorado state chairman of the organization. (James and Ann Maestas.)

Mr. James Beauty Salon, 1957. Upon returning from Korea, Maestas, following his uncle's advice, learned to cut hair. He bought a shop at 5038 Federal Boulevard; in this photograph, James is pictured with his aunt Toni Montoya Maestas. He eventually was appointed to the Colorado State Board of Cosmetology, serving as vice chairman and later chairman. He also served with the Small Business Administration. (James and Ann Maestas.)

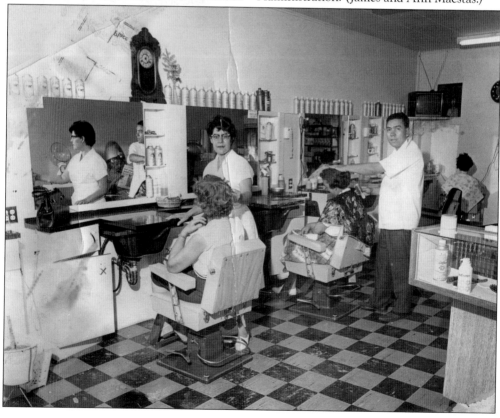

CANDIDATE MAESTAS, 1968 (RIGHT), AND MAESTAS FAMILY, 1981 (BELOW). James Maestas was one of the first Hispanic politicians in Colorado to align himself with the Republican Party; he ran unsuccessfully in three elections (once for city council, twice for the Colorado House of Representatives). Right, he and his wife Ann Maya Maestas pose in front of his campaign headquarters. James established deep northwest Denver roots, buying three adjoining properties on Tennyson Street. He took the photograph below in front of the family home at 4326 Tennyson Street. Pictured are, from left to right, Sasheen Arguello, Lauren Arguello D'Ascenz, Renea R. Maestas (James' and Ann's daughter), and Ann Maestas. (Both, James and Ann Maestas.)

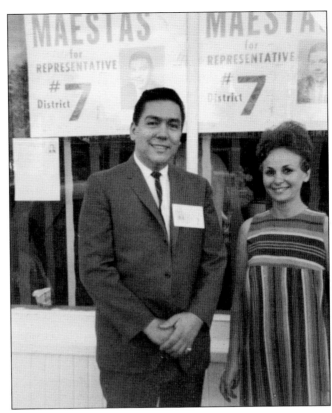

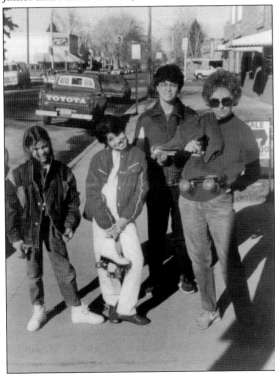

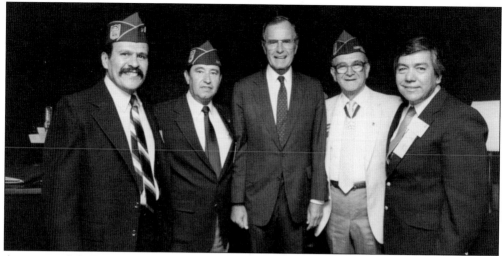

AMERICAN G.I. FORUM, 1984. Outraged by a funeral director's treatment of a Latino soldier, Hector Perez Garcia founded the American G.I. Forum to fight for Mexican American veterans' rights. In 1984, Maestas chaired the national convention. Pictured here are, from left to right, unidentified, Jake Alarid, Vice Pres. George H.W. Bush, Dr. Hector P. Garcia, and James Maestas. In 1988, Maestas worked on the Viva Bush Committee. (James and Ann Maestas; photograph by Dave Valdez, White House photographer.)

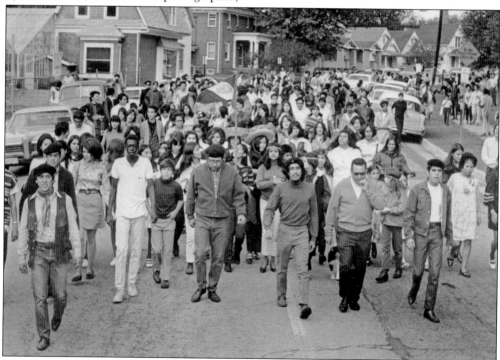

DIEZ Y SEIS DE SEPTIEMBRE, 1969. Demanding improvements to schools, Crusade for Justice leader Rodolfo "Corky" Gonzalez organized what he believed was "the largest congregation of Chicanos we've ever had" for a Mexican Independence Day rally at the Colorado state capitol. Its northwest Denver contingent, led by North High School student Rocky Hernandez, assembled in Highland Park before beginning a peaceful, police-escorted march downtown. (DPL, X-21610.)

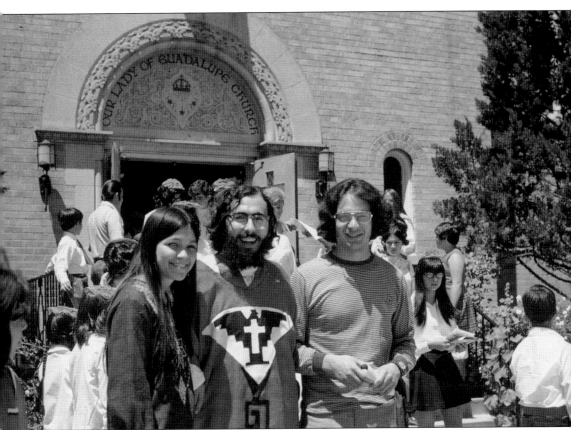

GUADALUPE CHURCH, 1971. Our Lady of Guadalupe, the primary church serving the Latino community on the north side, dates to 1936, when it began as a mission of St. Cajetan's Church. The present building, at West Thirty-sixth Avenue and Kalamath Street, opened in 1948. For 12 years, beginning in the late 1960s, Fr. José Lara was the activist pastor. Wearing a red sackcloth chasuble emblazoned with the Aztec eagle of the United Farm Workers of America (UFW), he stands with UFW grape boycott organizer Mary Ann Alonzo (left) and Denver boycott coordinator Chester Ruiz (right). Among Lara's innovations were a Mariachi Mass and a food bank. In 1981, Lara left the priesthood; in 1982, his friend Marshall Gourley, a non-Latino with a "zeal for Mexican tradition" became pastor. Equally concerned with social justice, Gourley helped raise $125,000 for Mexican earthquake survivors in 1985 and sought to reduce violence in Denver by encouraging people to surrender their guns. During the 1991 Persian Gulf War, 200 parishioners served in the military. (Mike Wilzoch.)

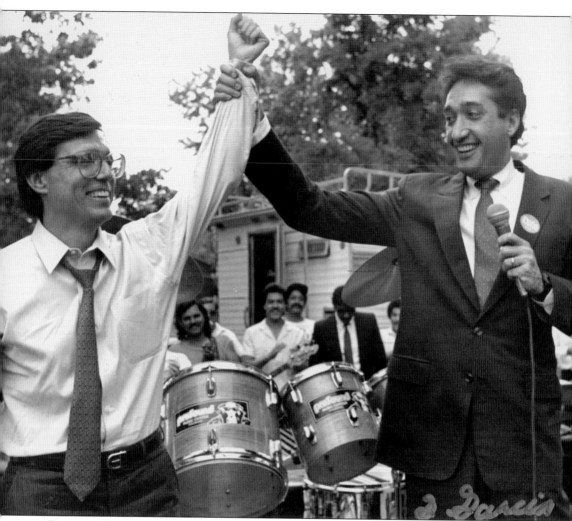

FEDERICO PEÑA, 1983. At Columbus/La Raza Park, 35-year-old mayoral candidate Federico Fabian Peña (left) campaigns with the help of San Antonio mayor Henry Cisneros. The Laredo, Texas, native moved to northwest Denver in 1972 and won a seat in the Colorado House of Representatives in 1978; in 1980, he became the house minority leader. Running against the incumbent, 72-year-old William McNichols, Peña emphasized his youth, and in 1983, he became the city's second-youngest and first Latino mayor. His campaign theme was "Imagine a Great City," and he steered Denver through difficult times; by the end of his second term, in 1991, Denver had a new convention center, a major-league baseball franchise, and a vast airport under construction. Most importantly, in Peña's view, he "open[ed] city government to people who didn't have access to it before," meaning women, racial and ethnic minorities, and the gay and lesbian community. Critics charged him with being captive to business interests, but Pres. Bill Clinton thought highly enough of Peña to make him his first Secretary of Transportation. (Shannon Garcia.)

Four

INSTITUTIONS, PRIVATE AND CIVIC

Thanks to air that was perceived as cleaner than central Denver's, Highlands, Berkeley, and north Denver were thought ideal for facilities devoted to health and wellness. One of Colorado's first hospitals, St. Luke's, opened on Federal Boulevard in 1881, but decamped to East Denver after a decade (see page 29). It was followed by the arrival of St. Anthony's in the 1890s, and Beth Israel in the 20th century. The Oakes Home operated as a residence for tuberculosis patients—not for serious cases, but for those who had a good chance at recovery. Although many dismissed his ideas as "quackery," Dr. John Henry Tilden attracted followers from all over the country who came to his complex of buildings on Highland Park to learn how to "cure" themselves of disease. After the Tilden School for Teaching Health closed, the buildings served health-related functions for years—one became a rest home, and another the Home for the Blind.

The northwest side also contained numerous facilities for the very young and very old. Mount St. Vincent's, St. Clara's, and the Queen of Heaven were three major orphanages, while the Old Ladies' Home and the J.K. Mullen Home catered to the needs of the low-income elderly.

From the beginning, children were an important constituency in the neighborhoods of the northwest side, and three libraries were built in the area in the early 20th century, all of them funded—like thousands of others—by Andrew Carnegie. During the Progressive era, children also benefitted from widespread concern for their wellbeing, with supervised playgrounds in all of the area's parks and the establishment of the Steele Gymnasium, which offered activities to fill the non-school hours.

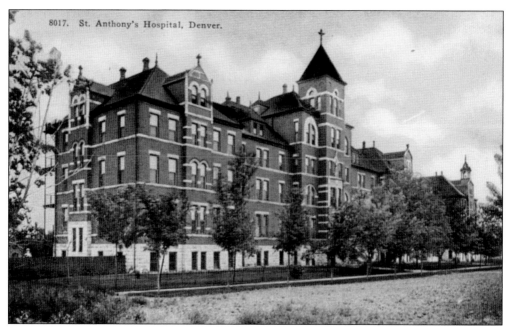

St. Anthony's Hospital, c. 1910. The Union Pacific Railroad invited the Sisters of St. Francis to run its northeast Denver hospital in 1883. By 1890, Denver's growth necessitated larger quarters, so the sisters built a 120-bed hospital near Sloan's Lake, far from city noise. In 1965, the ever-expanding hospital demolished this 1893 Romanesque-style building for a new wing. In 2011, St. Anthony's moved to Lakewood. (Author's collection.)

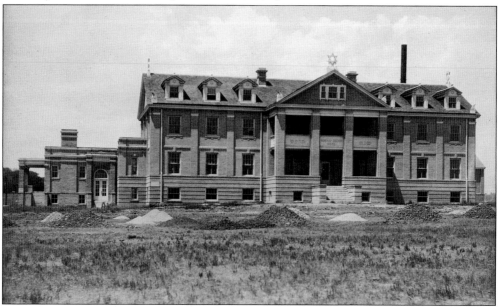

Beth Israel Hospital, 1923. At West Sixteenth Avenue and Lowell Boulevard, Beth Israel Hospital was completed in 1921, but lacked operating funds. In 1923, a $50,000 gift from retailer Leopold H. Guldman allowed the non-sectarian, 55-bed hospital to open, with an emphasis on geriatric care. Beth Israel expanded several times. St. Anthony's bought it in 1987 and eventually closed it. (DPL, X-28639.)

OLD LADIES' HOME, 1910. Facing West Thirty-eighth Avenue between Quitman and Raleigh Streets, the Old Ladies' Home was built between 1898 and 1900. It replaced an earlier (1876) building in Capitol Hill that, according to historian Jerome Smiley, was sold to a nearby resident who "had the building removed to relieve the neighborhood of its unsightliness." The new facility—built, like its predecessor, by the Ladies Relief Society—was designed by architect Walter E. Rice to be like a house. Residents were to be women "of good character," at least 65 years of age. They also had to be healthy—it was not set up for invalids. It is still open today, as a nonprofit operation offering independent and assisted living for both sexes. (Above, author's collection; below, DMF.)

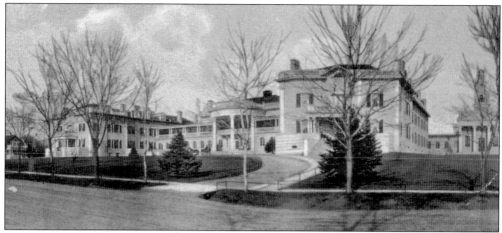

OAKES HOME, C. 1910. Rev. Frederick W. Oakes, rector of All Saints Episcopal Church (page 83), was the driving force behind "The Home," which was "not a sanitarium, a hospital, a boarding house or a hotel, but a home for a certain class of consumptives . . . people of culture and refinement, of brains and education" who came to Colorado to cure tuberculosis. Designed by Frederick J. Sterner and completed in 1896, it was financed largely by East Coast philanthropists. Facing West Thirty-second Avenue between Decatur and Eliot streets, it was elegantly furnished; indeed, Oakes argued with tax authorities to prove that it was actually "charitable" in nature, since it did not serve the indigent. Buildings such as the Schermerhorn Cottage (below), on West Thirty-third Avenue, were added later. (Above, author's collection; below, DPL, MCC-3951.)

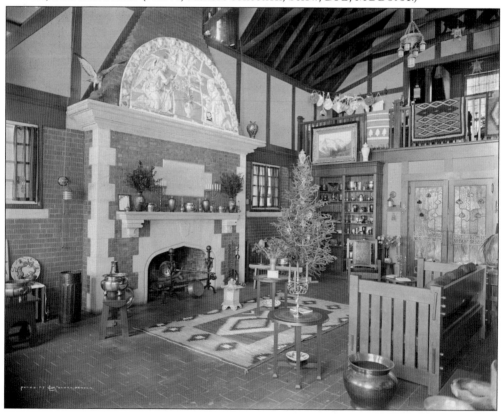

OAKES HOME CHAPEL, C. 1910
(RIGHT) AND 1912 (BELOW).
Reverend Oakes directed
the Oakes Home until 1934,
adding to the facility over
time. The Chapel of Our
Merciful Savior (now named
"Christ the King") was added
in 1903. It too was designed
by Frederick J. Sterner, who
clearly took inspiration from
Christopher Wren's London
churches. The Oakes Home
was taken over by the Episcopal
Sisterhood of St. Anne, which
closed it in 1941. The Sisters
of St. Francis purchased it in
1943 and put the building to
various uses, including as a
nuns' retirement home. They
sold it in 1974 to a different
order, which demolished
everything but the chapel and
later built the Gardens at St.
Elizabeth, a senior assisted-
living community, in place
of the Oakes Home. (Right,
DPL, X-28646; below, DMF.)

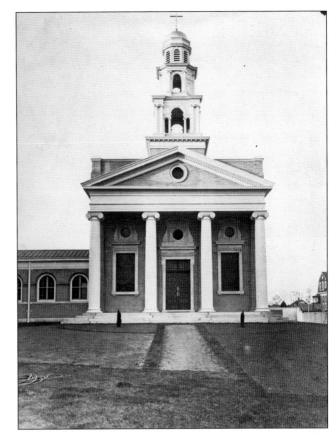

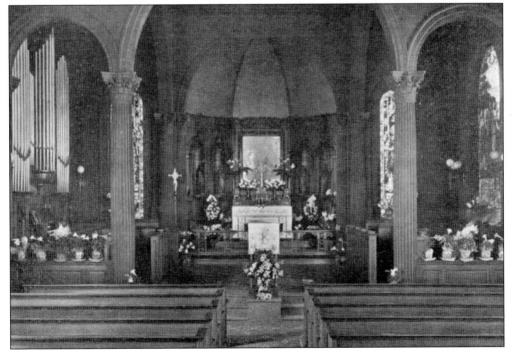

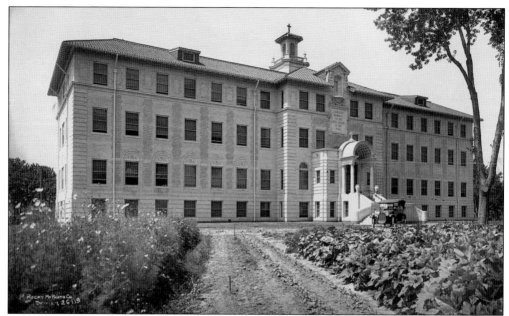

MULLEN HOME, C. 1920. Millionaire flour miller John Kernan Mullen funded this home for the elderly and asked Little Sisters of the Poor to run it. Centered on what was once Hiram Wolff's Sunnyside Nursery, at Lowell Boulevard and West Twenty-ninth Avenue, the Harry James Manning–designed facility opened in 1918 and has been in continuous operation since. (DPL, X-28920.)

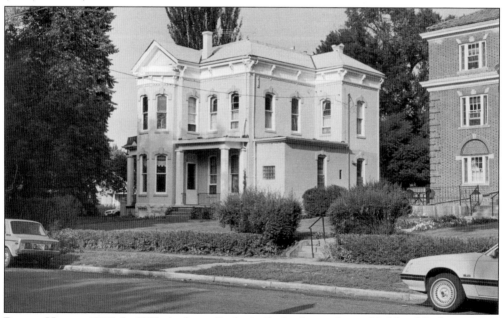

BOSLER HOUSE, 1983. In 1875, Ambrose Bosler built this house facing Highland Park, at Grove Street and Fairview Place. William H. Yankee bought it, selling it to Dr. John Henry Tilden in 1915. Tilden taught that toxemia was mankind's only disease—"right living" would cure it, he believed, and any other ailment, too. The house became the headquarters for his Tilden School for Teaching Health. (DPL, X-27138.)

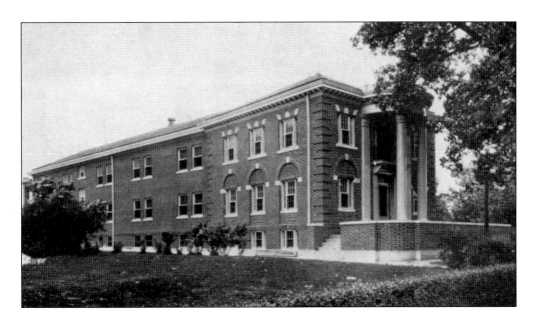

TILDEN SCHOOL, C. 1923 (ABOVE), AND OFFIELD HOME, C. 1946 (BELOW). Dr. John Henry Tilden commissioned other structures (all designed by Harry W.J. Edbrooke) to be built on adjoining properties, where his patients lived in apartments while they learned to "cure themselves." One of these, Building Number Three (above) faces the western end of Highland Park at Grove Street and Highland Park Place (formerly Bosler Place). After Tilden sold the school in 1924, this building became a home for the blind and is currently Heather Grove, an assisted-living home for military veterans. The "Main Building" (below), built in 1919 and expanded in 1923, is behind the Bosler residence on Fairview Place. For some years, it was the Offield Convalescent Home, and was converted to condominiums in the 1990s. (Both, author's collection.)

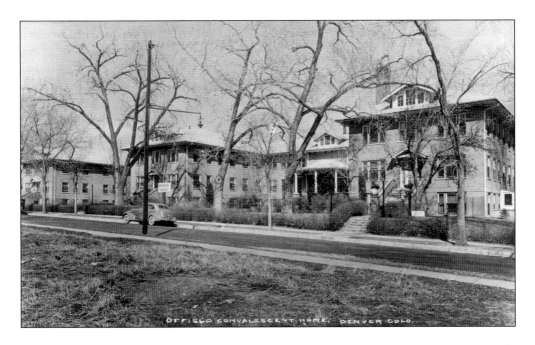

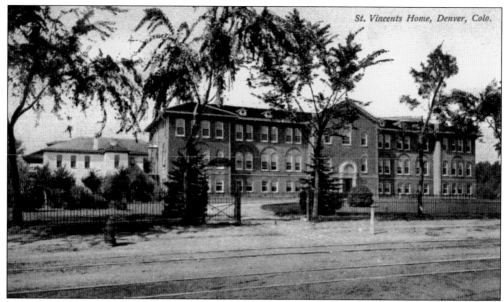

St. Vincents Home, Denver, Colo.

MOUNT ST. VINCENT'S HOME, 1910. In 1880, Catholic bishop Joseph P. Machebeuf determined that Denver needed an orphans' home. He began raising funds and finding a suitable location, ultimately accepting a donation of five acres on Lowell Boulevard at West Forty-second Avenue. William Quayle designed a two-story building, which opened in 1883 under the auspices of the Sisters of Charity of Fort Leavenworth, Kansas. A 1902 fire destroyed the original orphanage, which, at the time, housed 230 children. Students from College of the Sacred Heart, a mile away, rode over to assist in the rescue. The 1903 replacement pictured above was designed by Aaron M. Gove and Thomas F. Walsh and completed at a cost of $75,000. Below, the sisters and their wards pose for a group photograph. (Above, author's collection; below, *DMF.*)

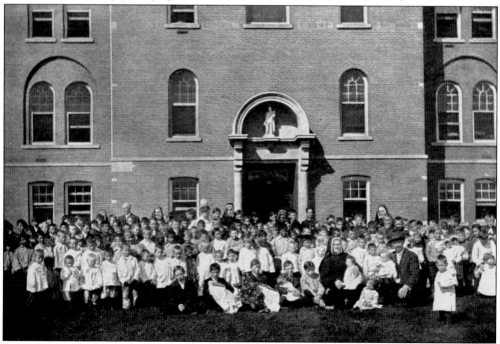

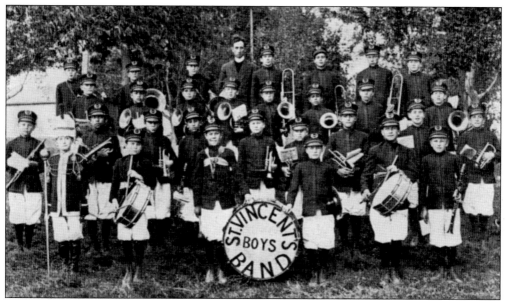

ST. VINCENT'S BOYS, 1911. The orphanage's band (above), all boys age 12 or younger, was frequently engaged to play at municipal playgrounds. Boys were engaged to learn in both academic and practical curriculums, including learning the printing trade (below). Mount St. Vincent's continued as an orphanage until 1969, when it was converted into a residential treatment facility and school for children with severe emotional or behavioral problems. Still operated by the Sisters of Charity as an organization independent from the archdiocese, Mount St. Vincent's has served over 18,000 children since 1883. (Above, *DMF*; below, DPL, X-29157.)

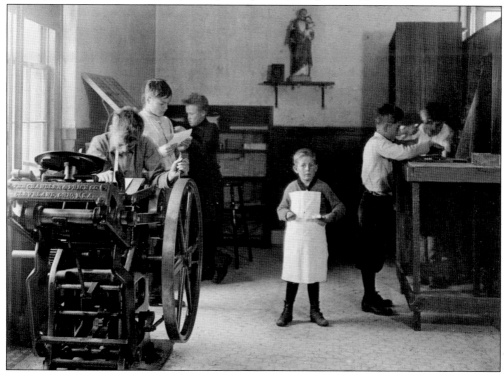

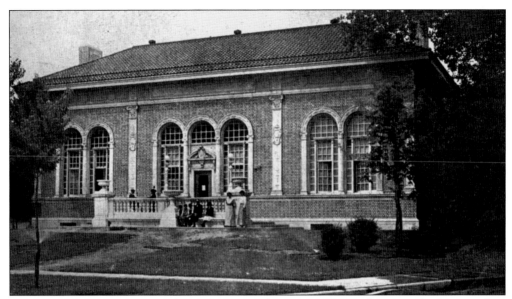

WOODBURY LIBRARY, 1913. Northwest Denver resident Roger W. Woodbury was the first president of the Denver Public Library board. Erected to memorialize him, this library in Highland Park at Thirty-third Avenue and Federal Boulevard was designed in Italian Renaissance style by Jules Jacques Benoit Benedict and funded by steel magnate Andrew Carnegie, whose portrait still hangs above one of the fireplaces. Opened in 1913, the library was expanded in 1966 (to a design by Oluf N. Nielsen) in order to increase its holdings to 50,000 volumes. It was renovated in 1992, with architect David Owen Tryba supervising. (Both, *DMF.*)

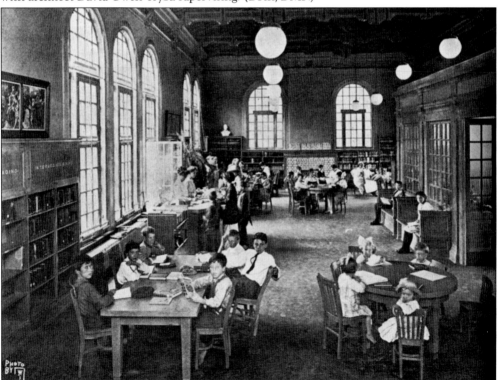

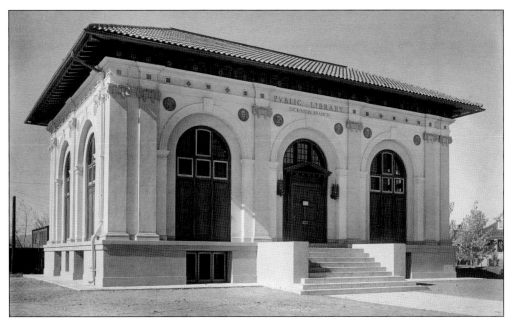

DICKINSON LIBRARY, 1914 (ABOVE) AND 1921 (BELOW). Another Andrew Carnegie–funded library, the Charles E. Dickinson branch opened in 1913 at 1550 Hooker Street to serve what was then a predominantly Jewish neighborhood along West Colfax Avenue. The children's department (below) was especially well patronized, and as they waited in line to check out books, young people could gaze at Allen Tupper True murals depicting frontier life. Teenage vandals ("thrill-seeking punks," the newspapers said) heavily damaged the library in 1953, and it closed permanently in 1954. Today, the building is a residence and the murals are in Wyoming. (Above, DPL, MCC-3676; below, *DMF.*)

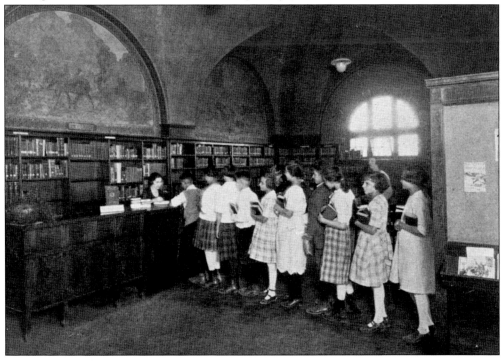

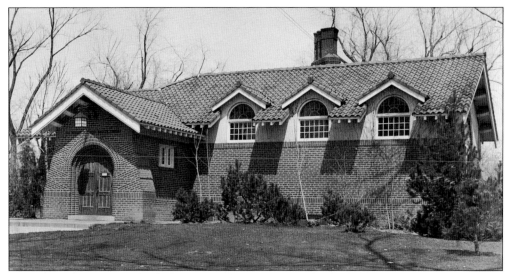

SMILEY LIBRARY, C. 1930 (ABOVE) AND 1959 (BELOW). A slightly later addition to Denver's roster of Carnegie-funded libraries, the William H. Smiley branch opened in Berkeley Park, at West Forty-sixth Avenue and Utica Street, in 1918. Frederick Mountjoy and Park French designed the L-shaped library to resemble an English cottage, and the initial collection of 4,000 volumes was heavily geared toward children's reading. The architects made the most of the limited square footage, placing most windows high enough that walls could be lined with books. Smiley, who was present at the dedication, was a Denver Public Schools superintendent. In 1980, in response to community requests, a "toy library" opened in the basement and was staffed by volunteers; children could check out donated toys and play with them for three weeks. (Above, DPL, X-20623; below, DPL, X-28140.)

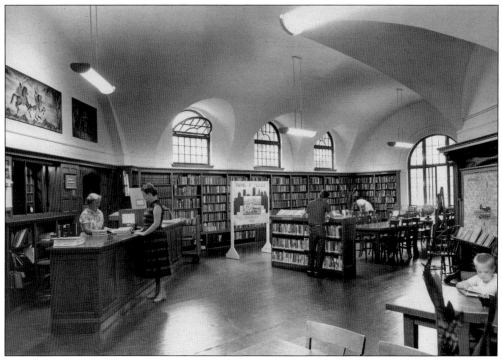

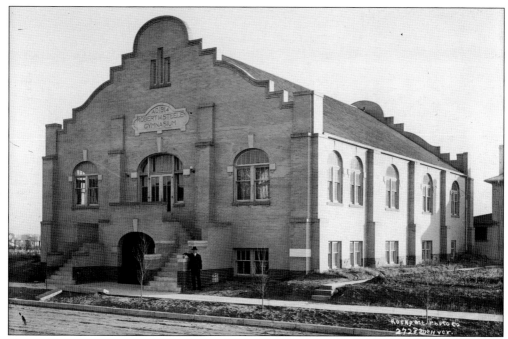

Steele Gymnasium, c. 1914. The Robert W. Steele Gymnasium opened in 1914 during a period when Progressives focused on the physical and moral development of boys. Designed by Robert Willison, the facility offered classes, team sports, and various activities. Today, the building at 3914 King Street houses Colorado Uplift, a non-profit organization teaching character, leadership, and life skills to urban youth. (DPL, X-29162.)

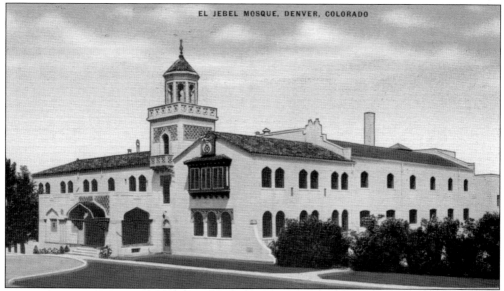

El Jebel Mosque, c. 1929. The El Jebel Shrine, the Denver branch of Shriners International, was chartered in 1888. In 1929, the Shriners moved from Capitol Hill to West Fiftieth Avenue and Vrain Street, buying the Rocky Mountain Country Club (formerly Interlachen) for its nine-hole golf course. Designed by William Norman Bowman and T. Robert Wieger, this Moorish-style building is still the Shriners' home. (Author's collection.)

69

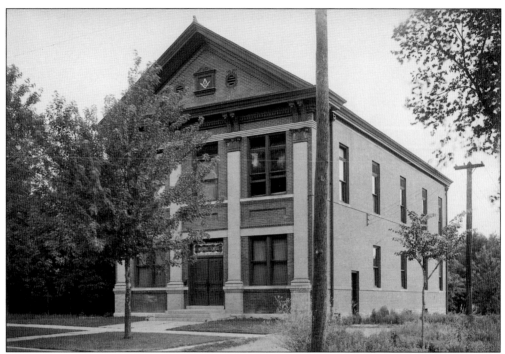

HIGHLAND MASONIC TEMPLE, C. 1910 (ABOVE) AND C. 1928 (BELOW). Although they were built within a few blocks and a few decades of each other and constructed for similar purposes, these two Federal Boulevard buildings have different personalities. The first (above), built in 1905 across from Highland Park near West Thirty-second Avenue, was replaced in 1928 by the still-in-use temple at West Thirty-fifth Avenue (below). Designed by Merrill Hoyt, it is home to six different Masonic lodges; the oldest, Highlands Lodge, was chartered in 1891 and was once the largest Masonic organization in Colorado. The Knights of Pythias occupied the old temple in 1934, and in 1993, Michael Delmonico renovated it as the Delmonico Hall events center. (Above, DPL, MCC-1929; below, DPL, MCC-3205.)

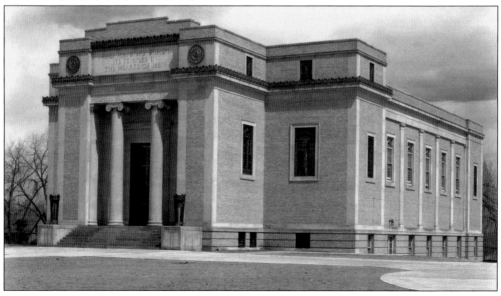

Five

SCHOOLS AND CHURCHES

To become "real" places, the communities of northwest Denver needed schools. Arapahoe County School District No. 17 was established in 1872 (before 1902, Denver County did not exist; District 17 was eventually consolidated with Denver School District No. 1). The first school, a single room, opened on the southern corner of Fifteenth and Central Streets in 1872, but quickly proved too small. Two years later, Ashland School replaced it, and others followed. Highlands resident William Quayle designed many of the early buildings, which were built in typical Victorian style and constructed with red brick. After consolidation with Denver, other northwest Denver residents, brothers Merrill H. and Burnham F. Hoyt, also contributed school designs. Many of the extant school buildings in northwest Denver compare quite favorably architecturally with schools in other parts of the city. Some truly unique-looking schools, like Bryant-Webster or Horace Mann, have no counterparts elsewhere.

Despite the northwest side's early Protestant origins, the borough quickly grew into a place of religious pluralism. Eastern European Jews clustered near West Colfax Avenue, building numerous small synagogues (the Arcadia Publishing volume *Jewish Denver: 1859-1940*, by Jeanne E. Abrams, PhD, includes a visual record of these institutions). Roman Catholics built St. Patrick's Church on Osage Street in 1882; as the first Catholic church in the area, it was the seedbed from which six other congregations sprang. Protestants were represented by Presbyterians, Methodists, Episcopalians, Congregationalists, and other mainline denominations, and many of the more charismatic or evangelical churches established northwest Denver outposts as well, including Jehovah's Witnesses, Baptists, and the Nazarene. The churches of northwest Denver are too numerous to fit into this volume; the included churches were chosen for their historical importance or their beauty.

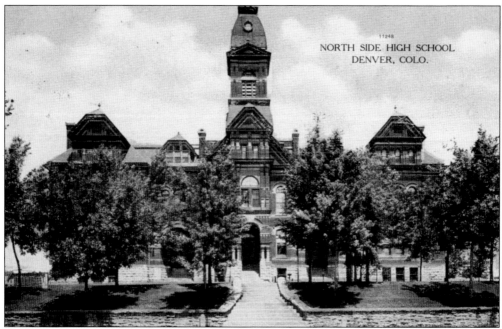

ASHLAND SCHOOL, C. 1900 (ABOVE) AND 1918 (BELOW). Ashland School opened in 1874 at West Twenty-ninth Avenue and Firth Court, on four acres donated by the Highland Park Company; it eventually expanded, adding more rooms and more grades. In 1889, a replacement (above) designed by William Quayle opened on the same site. While it was under construction, some classes were held in the nearby Arbuckle Building. Ashland High School graduated its first class in 1886, and after annexation by Denver, it became "North Side High School." North moved into a new building in 1911, and Ashland continued to house the primary grades; the 1918 graduates are pictured below. Ashland was demolished in 1975 and replaced by Jose Valdez Elementary, which was named for a World War II hero. (Above, author's collection; below, CRM.)

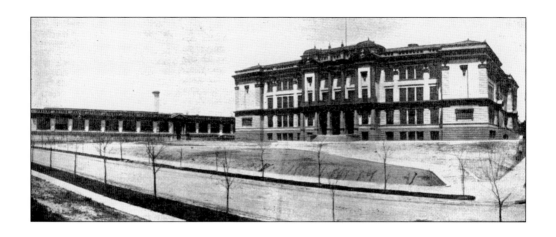

NORTH HIGH SCHOOL, 1912 (ABOVE) AND 1910 (BELOW). David W. Dryden designed the new North Side High School, completed in 1911 on Speer Boulevard and Ross Court. The beaux arts–style building served 700 pupils when it opened, and grew from there. In 1912, the one-story North Side Manual Training Shops wing (above, at left) was added for students seeking vocational training. North's sports teams, including baseball (below), have always—appropriately—been the Vikings. The school's famous alumni include Israeli prime minister Golda Meir and "King of Jazz" Paul Whiteman. Actress Spring Byington, Lakeside owner Rhoda Krasner, and historians Ruth Eloise Wiberg and Caroline Bancroft also attended North. Denver's municipal flag was designed by North student Margaret Overbeck. (Both, *DMF*.)

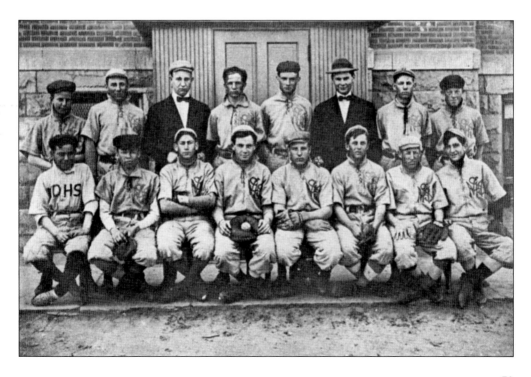

73

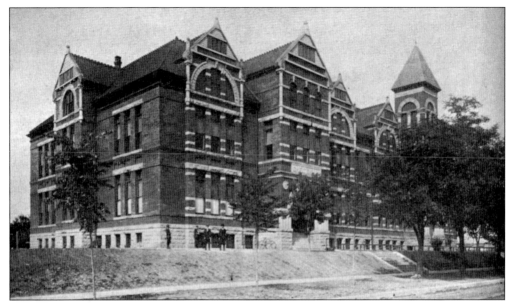

CHELTENHAM SCHOOL, 1912. Serving the largely Jewish neighborhood along West Colfax Avenue, Cheltenham opened in 1891 at the intersection of Colfax and Irving Streets. In the 1920s, the Cheltenham Annex was an "open air" environment where tubercular children learned while exposed to fresh air—in all weather. The building was decrepit by the 1960s, and, after neighborhood agitation, the school board replaced it. (DMF.)

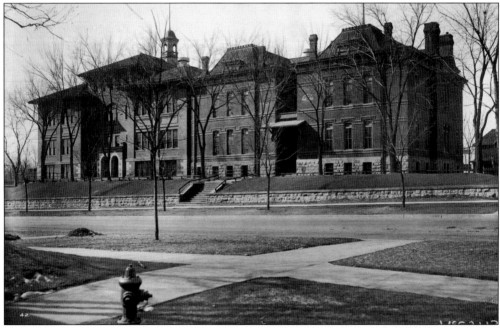

BOULEVARD SCHOOL, C. 1910. In 1883, when Federal Boulevard was simply "Boulevard," this William Quayle–designed school opened to serve the Witter-Cofield subdivision. It was enlarged in 1891 and again in 1904 to accommodate the 900 students who required education. The older wings were demolished in 1962, the school closed in 1982, and it was subdivided into residences in 1985. (DPL, MCC-3793.)

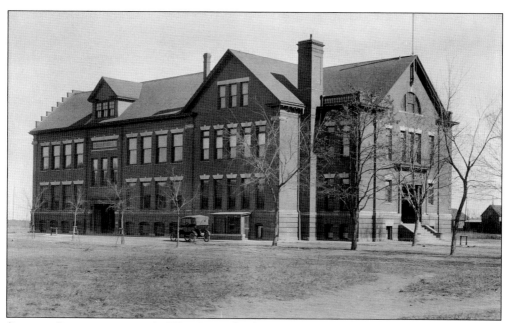

SMEDLEY SCHOOL, C. 1910. At West Forty-third Avenue and Shoshone Street, Smedley School opened in 1902 and closed in 2007. Namesake William H. Smedley was a dentist (and school board member) who came to Denver for his health in 1870. Desiring pure air, he studied wind patterns before determining that he should build his house at West Thirty-fifth Avenue and Pecos Street. (DPL, MCC-3871.)

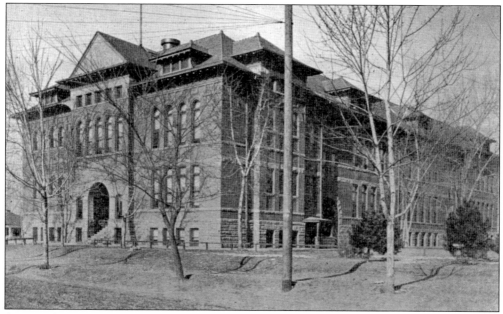

ALCOTT SCHOOL, 1912. Louisa May Alcott School, at West Forty-first Avenue and Tennyson Street, opened in 1892 and expanded several times before becoming the fully built structure seen here. The school served several generations before closing in early 1976. Arson destroyed Alcott on the night of March 25, 1976, just before it was to be demolished; Cesar E. Chavez Park occupies the site today. (DMF.)

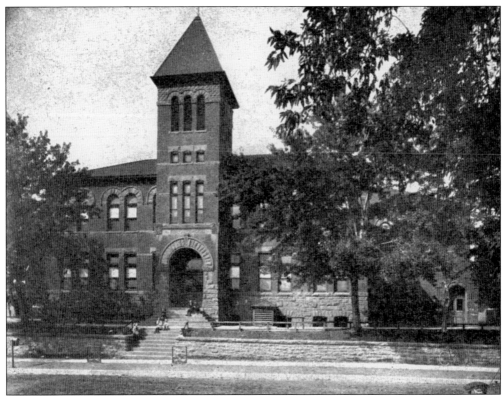

Edison School, 1912 (above) and c. 1925 (below). Thomas Alva Edison School (above) opened in 1892 on Quitman Street just north of West Thirtieth Avenue. Designed in Richardsonian Romanesque style by John J. Huddart, it originally had four rooms; additions came in 1900 and 1902. Hemmed in by houses, the school could not expand further, so the school board purchased the block between Quitman and Perry Streets and West Thirty-third and West Thirty-fifth Avenues. The new Edison (below), designed by Robert K. Fuller in an English Tudor style, opened in 1925. Board members used the dedication ceremony to push a bond issue for more schools. Edison was expanded in 1951 (overcrowded this time with baby boomers) and again in 1994. In 1947, 18 sets of twins were enrolled at Edison. (Above, *DMF*; below, DPL, MCC-3725.)

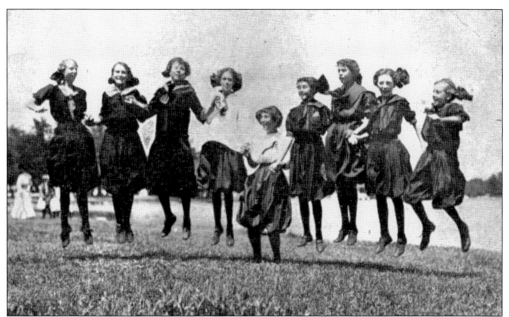

COLUMBIAN SCHOOL, 1911 (ABOVE) AND 1983 (BELOW). In 1892, 400 years after a famous voyage, the name "Columbus" was in vogue, so the school built that year at West Forty-first Avenue and Federal Boulevard, near Denver's Italian settlement, was given the name "Columbian." Above, the girls' captainball (similar to basketball) team won a citywide "Play Festival" sponsored by Mayor Robert W. Speer. In the late 1970s, the school board decided that the building was inadequate. In 1985, despite preservationists' outcries and a request by State Representative Phil Hernandez that Columbian be renovated, it was demolished and a replacement was built. The school's Parent Teacher Student Association supported demolition; one parent told the *Rocky Mountain News* that in such a poor neighborhood, renovation would be a "frill." (Above, *DMF*; below, DPL, Z-10801.)

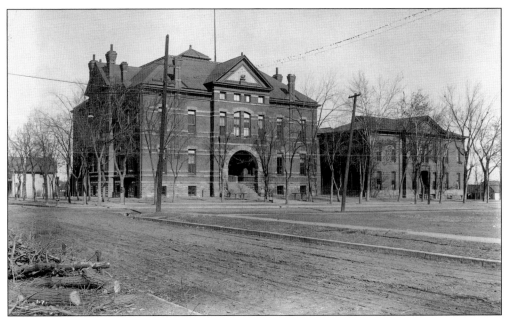

BRYANT SCHOOL, C. 1910. Around 1880, Ashland School was overcrowded, so District 17 built a school named for William Cullen Bryant at West Thirty-second Avenue and Shoshone Street. Despite two expansions, by 1890 it too was inadequate, which led to the construction of this school four blocks north on Shoshone Street. Over 1,000 students, primarily children of immigrants, were enrolled by 1900. The school was demolished in 1931. (DPL, MCC-3783.)

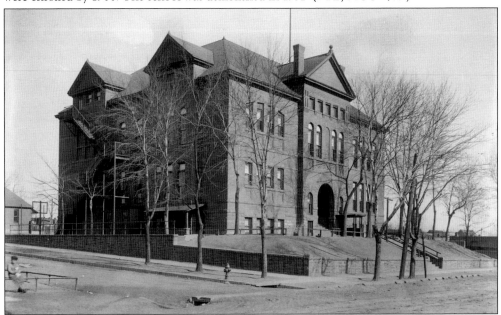

WEBSTER SCHOOL, C. 1910. Just a few blocks away from Bryant, at West Thirty-sixth Avenue and Lipan Street, the William Quayle–designed Daniel Webster School opened in 1892. In 1916, it began offering Evening Opportunity School classes, including typing, home economics, English, and, for immigrant adults, citizenship classes. Principal Lillian Noce paid for books and materials herself. (DPL, MCC-3792.)

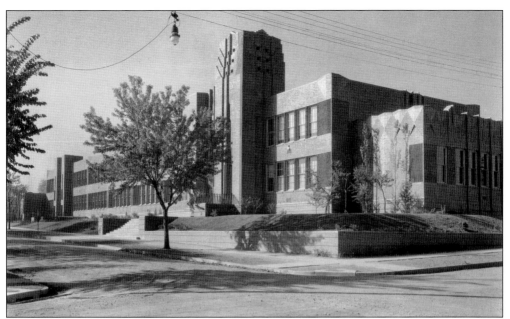

BRYANT-WEBSTER SCHOOL, C. 1931. Denver Public Schools decided to combine Bryant and Webster in 1930. At West Thirty-sixth Avenue and Quivas Street, architect George Meredith Musick created a Pueblo Deco–style masterpiece. Using custom-made bricks, his facade incorporated Navajo textiles, Pueblo pottery, buffalo, and other Native American motifs, in decided contrast to the predominantly Italian culture then prevalent in the neighborhood. (DPL, X-27558.)

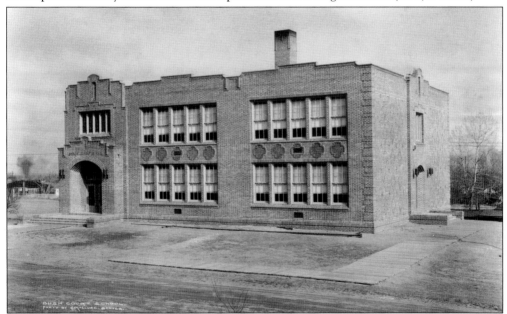

BEACH COURT SCHOOL, C. 1929. Serving a semi-rural area of truck farms interspersed with houses when it first opened on Beach Court and West Fiftieth Avenue in 1929, Beach Court grew larger as the area filled in. It was designed by George Meredith Musick in a much simpler style than that of Bryant-Webster. Long ranked low within the school district, in recent years Beach Court has shown improvement and has been positively cited for it. (DPL, MCC-4004.)

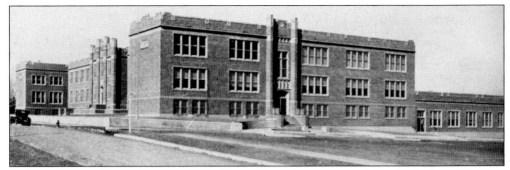

SKINNER JUNIOR HIGH SCHOOL, 1923. Named for Alcott principal Elizabeth Hope Skinner, this junior high school, the first in Denver, opened in 1922 at West Forty-first Avenue and King Street to serve more than 1,000 pupils. In 1977, a white teacher circulated a mock "minority job application" that was derogatory toward African Americans and Latinos at a time when the school's population was predominantly Latino; despite protests, the teacher kept his job. Racial and ethnic tensions continued at the school for several years after the incident. (*DMF.*)

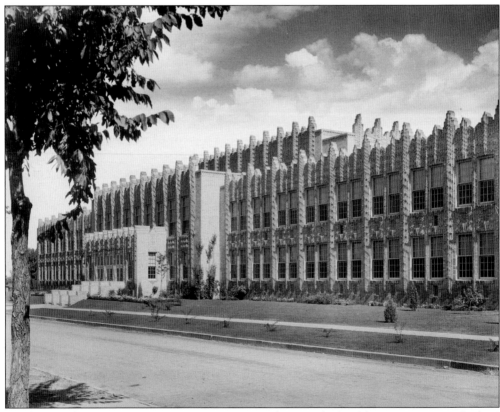

HORACE MANN JUNIOR HIGH SCHOOL, 1940. A tribute to the bricklayer's art, "Deco Gothic" describes the 1931 design, by Temple Hoyne Buell, of Horace Mann Junior High School. At 4130 Navajo Street, it was one of 26 Denver schools designed by the prolific Buell, who originally came to Colorado for his health and briefly stayed in the Oakes Home. (DPL, Roy Hyskell, X-28460.)

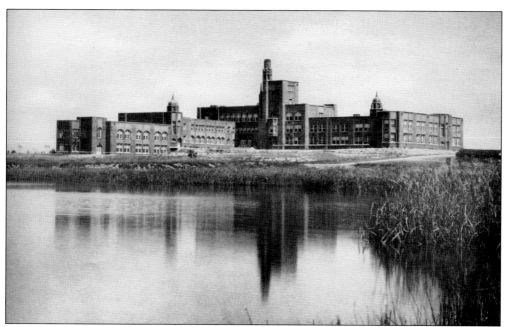

LAKE JUNIOR HIGH SCHOOL, 1930. A jewel of Denver Public Schools, Lake Junior High opened in 1926 on the eastern shore of Sloan's Lake. Designed by Merrill H. and Burnham F. Hoyt in Tudor Revival style, it also incorporates Middle Eastern–influenced domes and spires. With its dramatic setting, *Denver Municipal Facts* enthused that "there is not to be had in Denver a more commanding uninterrupted view of the mountains than from the windows of this school." The grounds were designed by M. Walter Pesman to be educative, incorporating a large variety of trees and plants. In 1987, an alumnus, Chief US District Judge Sherman Finesilver, recounted to the *Rocky Mountain News* an important lesson taught by a Lake teacher, after his class witnessed groups of Japanese Americans being sent to internment camps, about "how even governments can make mistakes." (Both, *DMF*.)

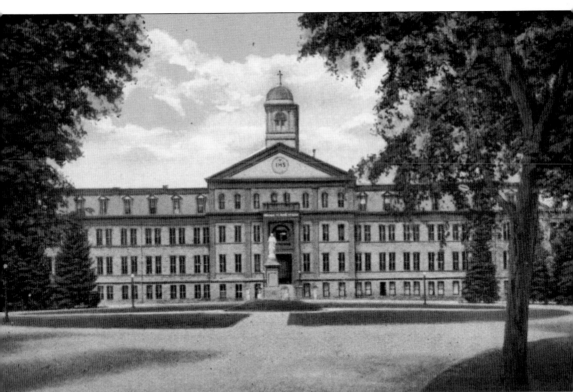

COLLEGE OF THE SACRED HEART, C. 1912. Northwest Denver's institution of higher learning, Regis University, was founded in 1877 in Las Vegas, New Mexico, by a group of exiled Italian Jesuits. After seven years as "Las Vegas College," Bishop Joseph P. Machebeuf invited the school to move to Colorado, where it opened in Morrison as College of the Sacred Heart. Berkeley developer John Brisben Walker hoped to curry favor with the church and attract high-class people to his town, so he donated 50 acres to the college in 1887. He stipulated that the building must be at least 297 feet long, 60 feet high, and made of stone. Father Dominic Pantanella, Edward Barry (a novice), and architects Henry Dozier and Alexander Cazin came up with this Second Empire design; the walls are sandstone and rhyolite. In 1921, the school changed its name to "Regis College" in honor of John Francis Regis, a Jesuit saint, and because Sacred Heart's Catholic-sounding name might draw attention from a then-ascendant Ku Klux Klan; it attained university status in 1991. (Author's collection.)

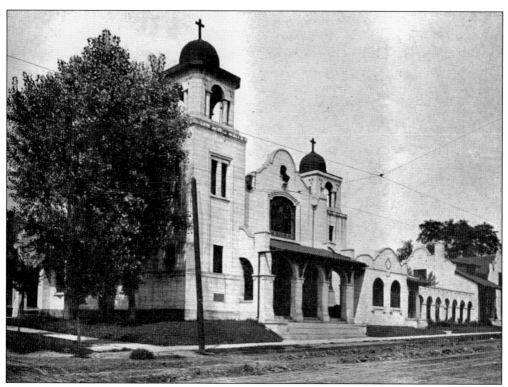

ST. PATRICK'S MISSION CHURCH, 1912.
St. Patrick's, the first Catholic parish
in Northwest Denver, opened in 1882
at West Thirty-third Avenue and
Osage Street. In 1907, Father Joseph
P. Carrigan commissioned a new,
California Mission Revival church
one block west at Navajo Street,
designed by Harry James Manning and
Francis Wagner. Carrigan fought with
Bishop Nicholas Matz over the project
and was briefly excommunicated
for "open rebellion." (*DMF.*)

**ST. CATHERINE OF SIENA CHURCH,
1963.** In 1912, Bishop Nicholas Matz
authorized the creation of a new parish
for residents of Harkness Heights.
The first St. Catherine, at West Forty-
second Avenue and Federal Boulevard,
was dedicated in 1915. Overcrowding
led to its demolition and replacement
with this John K. Monroe–designed
Romanesque sanctuary, dedicated
in 1952. The interior features
elaborately decorated trusses
supporting the roof. (DPL, X-25395.)

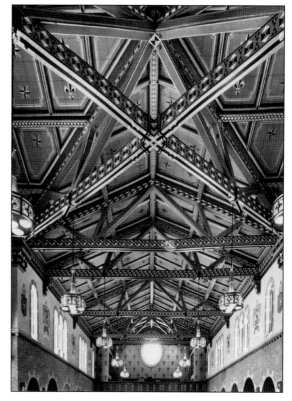

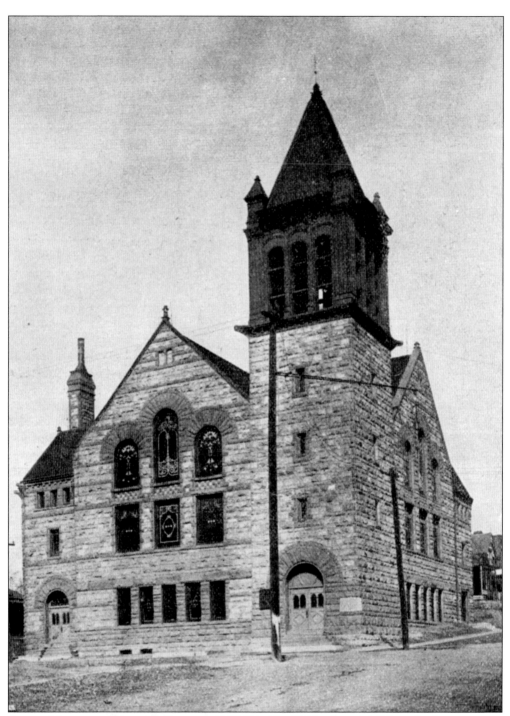

ASBURY METHODIST EPISCOPAL CHURCH, 1909. Franklin Kidder designed Asbury for the prominent corner of West Thirtieth Avenue and Vallejo Street, making this 1890 Richardsonian Romanesque landmark visible from downtown. Built of rhyolite and Manitou sandstone, its rough-hewn character was well suited to its original congregation, many of whom were former miners of Welsh and Cornish heritage. It houses the oldest working pipe organ in Colorado. (*DMF.*)

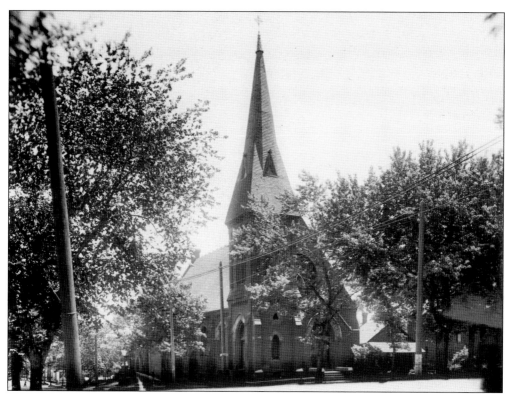

ALL SAINTS EPISCOPAL CHURCH, C. 1910. Bishop John Franklin Spalding organized the All Saints congregation in 1874. Initially located at Fifteenth and Central Streets, the church moved in 1890 to this red brick Gothic structure (above) at West Thirty-second Avenue and Wyandot Street. The Welsh and Cornish who worshipped as Episcopalians rather than Methodists joined All Saints, along with north Denverites from Scotland and England and Germans who worked at Platte River breweries. Rev. Frederick W. Oakes became rector in 1894; he launched the Oakes Home (pages 58 and 59) from this base. After the congregation moved in 1961, the Episcopalians rechristened the building "Chapel of Our Merciful Savior," as the original Oakes Home chapel had become Roman Catholic. (DPL; top: X-25490; below, MCC-3809.)

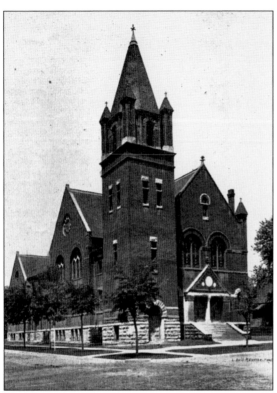

BOULEVARD CONGREGATIONAL CHURCH, 1912. This church opened at 2601 Federal Boulevard in 1896. Architect Franklin Kidder lived across the street and purportedly once said, "I am a doctor of philosophy, a member of the Boulevard Congregational Church and the American Institute of Architects. When I fulfill the obligations of those callings I will have done all that is expected of a man." The church was demolished in 1972. (*DMF.*)

ST. DOMINIC CHURCH, 2011. While in Colorado recovering from tuberculosis, Father Joseph Murphy worked with Catholic residents of Witter-Cofield to build the first St. Dominic at West Twenty-fifth Avenue and Grove Street in 1890. In the 1920s, the Ku Klux Klan was active in Colorado and burned a cross on its lawn. Despite Klan opposition, the parish dedicated this larger, Robert Willison–designed church, at West Twenty-ninth Avenue and Federal Boulevard, in 1926. (Author's collection.)

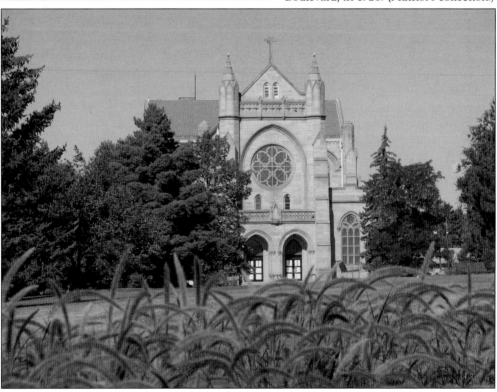

Emmaus Lutheran Church, 1912.
Named for a village near Jerusalem, the
Emmaus congregation was established
on Irving Street and West Thirty-first
Avenue in 1907. After constructing a
temporary church that year, they replaced
it with this building in 1912. In 1952,
this church was demolished for a new
sanctuary next door. The church has run
a primary school since 1908. (*DMF*.)

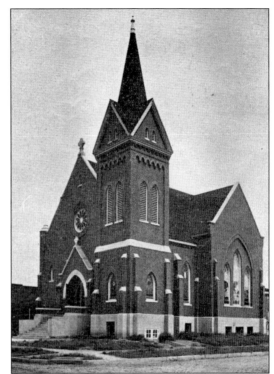

**Fourth Church of Christ, Scientist,
c. 1921.** This V-shaped neoclassical
church, designed by Burnham and Merrill
Hoyt, opened in 1920 at West Thirty-first
Avenue and Speer Boulevard, on the
opposite end of the block from Emmaus
Lutheran. The Christian Scientist
congregation that commissioned it was
established in 1891. In 1998, the Denver
Zen Center bought the building from
the dwindling congregation for Buddhist
worship and education. (DPL, X-25441.)

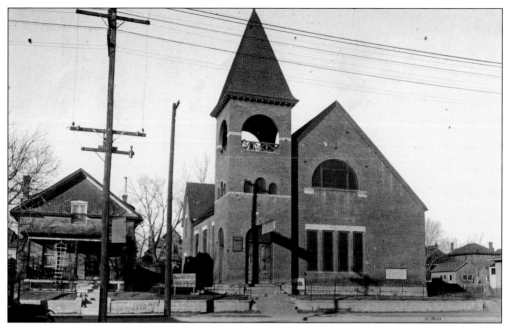

BETH EDEN BAPTIST CHURCH, C. 1915. A Baptist congregation built this small church on Lowell Boulevard and West Moncrieff Place in 1892. The church later bought adjoining lots for expansion, remodeling the original in the Tudor Revival style popular in the 1920s and 1930s. In 1961, the church built nearby Eden Manor, a 12-story apartment tower for seniors. (DPL, X-27821.)

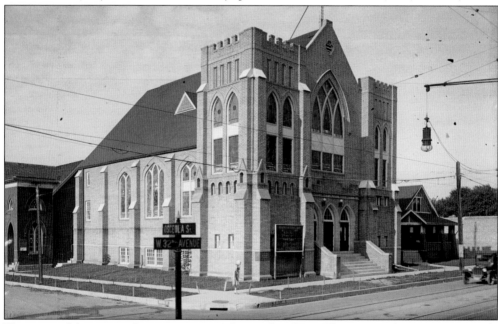

HIGHLANDS METHODIST CHURCH, C. 1926. Located on West Thirty-second Avenue at Osceola Street, the Highlands Methodist congregation dates from 1890, when area Methodists met in tents and homes. They built a church in 1896, visible behind this later Arthur S. Wilson–designed building, which was completed in 1926. The parsonage, built in 1915, is to the right of the church. (DPL, X-25336.)

Six

LAKES AND PARKS

After Highlands merged with Denver in 1896, residents began agitating for parks similar to those in other parts of the city. In 1898, a North Side Improvement Society pointed out that Capitol Hill had about 550 acres devoted to parks (including City Park), east Denver had 15, west Denver had 18, yet north Denver (east of Zuni Street) and Highlands together had just four acres—all at Chaffee Park. The city was spending $70,000 annually to beautify Capitol Hill parks, but less than $200 on the northwest side. Although many in the northwest area wanted something as large as City Park, preferably with swimming pools and mountain views, the available money ($28,000) paid for just two small parks: Jefferson and Highland.

However, when Robert W. Speer became mayor in 1904, he worked to build new parks in all quadrants of the city, and the northwest side soon had parklands at its three major lakes (Berkeley, Rocky Mountain, and Sloan's, although it took until 1936 to assemble the entirety of Sloan's Lake Park). Speer envisioned a system of parkways to connect the parks; east Denver's parkways got built, while northwest Denver's did not.

Over the rest of the century, a few additional parks were added, including Columbus Park (in the heart of the Italian district), and Viking Park (in the triangle facing North High School, bordered by Federal and Speer Boulevards and West Twenty-ninth Avenue). Creation of this last park, built between 1979 and 1984, necessitated the demolition of a number of historic properties. Due to its proximity to major roadways, and a lack of parking, Viking Park is little used. Columbus Park, on the other hand, has been heavily patronized since it was created in 1931 on West Thirty-eighth Avenue and Navajo Street. As the area transitioned from predominantly Italian to Latino, area youth rechristened it "La Raza Park" (la raza means "race" in Spanish). Area Latinos went before city council in 1988 to have the name officially changed, or modified to "Columbus–La Raza," but the motion was defeated.

Jefferson Park, 1912. Named for the "patron saint of the Democrats" (per the *Denver Times*), Jefferson was one of the two initial parks funded by Denver after the Highlands annexation. The site, between Clay and Eliot Streets and West Twenty-second and Twenty-third Avenues, was originally a "hole in the ground," and the original 1899 landscaping plan was designed to take advantage of its hilly topography. (*DMF.*)

Highland Park, 1912. Highland Park Hotel opened at West Thirty-second Avenue and Federal Boulevard in 1875, with "fresh air" and a small lake as its chief attractions; the hotel burned down after a few years. Charles Hallack then used the land as a nursery, planting what would become Highland Park with trees and selling it to the city for $18,000 in 1899. Improvements were made under the Speer administration, including the addition of a tennis court. (*DMF.*)

McDonough Park, c. 1935. Named for the then-recently deceased John McDonough in 1912, the park at Federal Boulevard and West Forty-first Avenue was one of the smaller ones added under Mayor Speer. McDonough worked for the syndicate that purchased Berkeley Farm, and thus was instrumental in northwest Denver's development. He also developed the Harkness Heights subdivision, which includes the park. (DPL, X-20323.)

Sunday Afternoon, 1914. It is unclear whether the photographer of this Berkeley Park scene was familiar with Georges Seurat's 1884 masterpiece, *Un dimanche après-midi à l'Île de la Grande Jatte*, but the compositional similarity is striking. In 1914, the city estimated that as many as 1,500 people enjoyed the waters and beach of Berkeley Lake on a typical summer weekend afternoon. (*DMF.*)

Berkeley Bathers, c. 1918 (above) and 1913 (below). The Rocky Mountain Ditch Company developed the natural lake at Berkeley into a reservoir, and it was the scene of hunting tournaments in 1891. By 1902, it was the "Berkeley Family Resort," site of numerous illegal "beer picnics" that were the bane of neighbors and the temperance-favoring town of Berkeley. John Brisben Walker bought the lake in 1903 for a proposed country club, but it never came to fruition. After Denver bought the lake in 1906, its development as a park occurred in stages; the swimming pier was new in 1913 (below), and the beach was well maintained and heavily patronized (above). In the 1950s, polluted water ended the lake's days as a swimming hole. (Above, DPL, X-27150; below, *DMF.*)

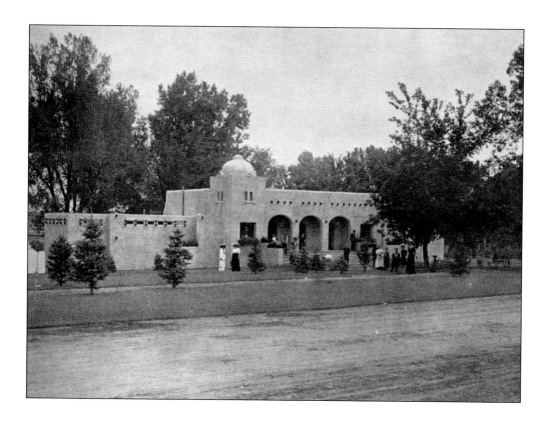

BERKELEY PARK, 1913 (ABOVE) AND 1912 (BELOW). The Bath House (above) was new in 1913; the California Mission–style building, with showers and changing rooms, was near the site of the old Berkeley Family Resort's dance pavilion. Ice skating (below) was popular in the park's early years, and the city built a warming house and skate rental facility (skating is no longer allowed). Not far from the site of the Bath House, a new building, the Berkeley Recreational Center (later renamed for former City Councilman William Scheitler), opened in the 1970s to provide the swimming opportunities lost years before when the lake was closed to swimming. The center is located next to a triangle of land that was added to the park in 1967; its parking lot follows the route of a de-mapped street, "Short Yates," that connected Yates Street with Sheridan Boulevard. (Both, DMF.)

BERKELEY PLAYGROUND, 1910. The Speer administration was quite proud that all equipment at city playgrounds was designed and built by Denver's parks department; *Denver Municipal Facts* claimed that this saved the city substantial sums of money. Product liability lawsuits were uncommon in 1910; it would be difficult to imagine such dangerous equipment in the park today. (*DMF.*)

FROM INSPIRATION POINT, 1912. Berkeley Park was tranquil in 1912; today, Interstate 70 would run through the center of this photograph. The "senseless travesty" of the freeway's construction prompted an angry letter to the *Denver Post* in 1964, giving a sarcastic "tip of the money hat to Mr. [Gerri] Von Frellick [the pro-freeway developer of nearby Lakeside Shopping Center] . . . who once again proved that might makes right." (*DMF.*)

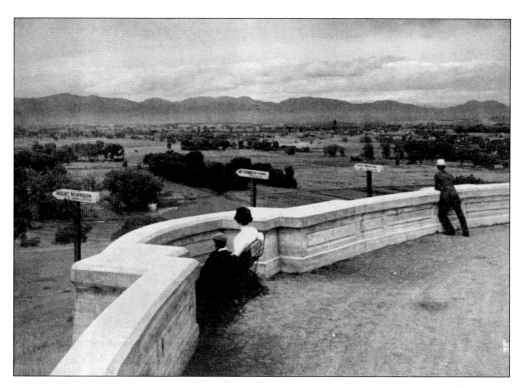

INSPIRATION POINT, 1912 (ABOVE) AND 1914 (BELOW). In 1906, John Brisben Walker again demonstrated his commitment to Berkeley when he donated to the city a strip of land west of Sheridan Boulevard, northwest of Berkeley Park. In 1909, Mayor Robert Speer authorized $6,000 for the land leading up to it, and Denver's newest tourist attraction was born. Speer built a 700-foot-long wall wrapping around the point, as well as an access road. *Denver Municipal Facts* described its allure: "It sweeps the range from Pike's Peak to Long's Peak. Torrey's Peak, James Peak, Arapahoe Peaks, [and] Mount Audubon cut its horizon into mightily and wonderfully jagged shapes. It is the climacteric [*sic*] point of Denver's boulevard system." In 1914, the city staged a skiing demonstration on Inspiration Point's northern slope (below). (Both, *DMF.*)

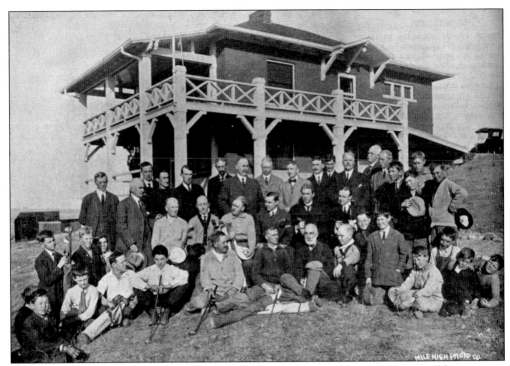

INTERLACHEN GOLF CLUB, 1912. The Interlachen Golf Club formed in 1912, building a nine-hole course, complete with clubhouse, north of West Fiftieth Avenue between Vrain Street and Sheridan Boulevard. Interlachen had additional holes around Inspiration Point, west of Sheridan Boulevard. In 1924, the club, renamed "Rocky Mountain Country Club," sold the course to El Jebel Shrine (page 69). (DMF.)

BERKELEY GOLF COURSE, 1930. In 1929, the city built a nine-hole course north of Berkeley Lake, south of West Fiftieth Avenue. In 1934, stockbroker Willis Case was murdered by his girlfriend. His will left $113,000 to Denver to expand its golf facilities, so the city bought the course from the financially strapped Shriners. The avenue was removed, and the combined 18 holes were named for Case. (DMF.)

ROCKY MOUNTAIN LAKE PARK, 1911 (ABOVE) AND 1919 (RIGHT). Rocky Mountain Lake, on Forty-sixth Avenue between Federal and Lowell Boulevards, is a natural body of water. In the 1880s and 1890s, Laura Taylor ran a summer resort. She equipped it with over 40 rowboats and a pavilion serving "temperance refreshments." By 1903, it had been taken over by the Eastern Amusement Company for an illegal gambling operation. The Speer administration bought the lake in 1906 and eventually opened a free automobile camp for tourists. By 1919, according to the *Denver Post*, it was hosting between 175 and 200 campers per day, who could take advantage of bathing beaches, "excellent black bass fishing," children's playgrounds, shelters with stoves "worked by a nickel in the slot," and Taylor's pavilion, now used for dancing. (Both, *DMF.*)

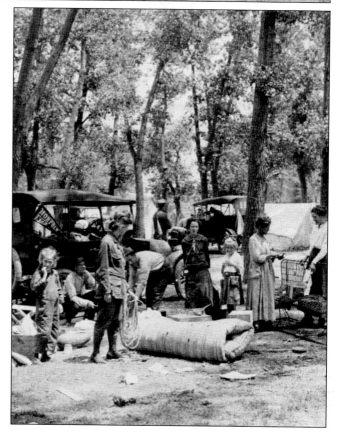

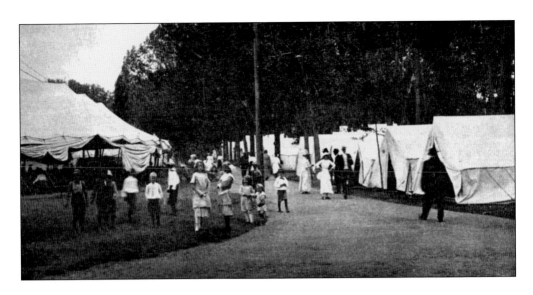

ADVENTIST ENCAMPMENT, 1913. Rocky Mountain Lake Park was also used as a campsite for Colorado Seventh Day Adventists, who met there each year from about 1910 through at least 1919. Representatives from every Adventist church in Colorado came, with 250 tents pitched in neat rows for the 10-day meeting. Delegates were roused for early morning (6:00 a.m.) sessions, and various meetings and services ran throughout the day. At 8:00 p.m. each night, more than 1,000 people packed a large tent for the main service. The camps were run in a militaristic fashion, complete with a cafeteria and a "sanatorium" [sic] tent staffed by doctors and nurses. On the final day, the newly converted were baptized in the lake. (Above, DMF; below, author's collection.)

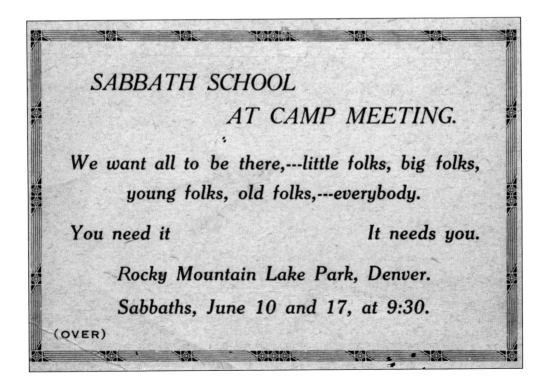

SABBATH SCHOOL

AT CAMP MEETING.

We want all to be there,---little folks, big folks, young folks, old folks,---everybody.

You need it It needs you.

Rocky Mountain Lake Park, Denver.

Sabbaths, June 10 and 17, at 9:30.

(OVER)

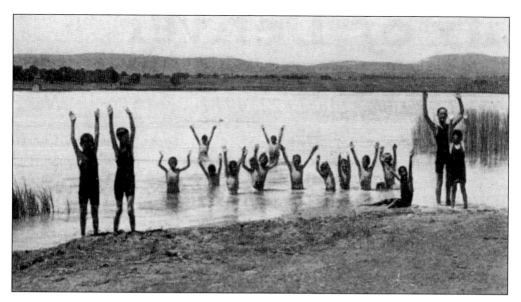

SLOAN'S LAKE PARK, 1914. After Denver annexed Highlands, many new northsiders did not consider Sloan's Lake appropriate for a "north side" park, considering it a part of west Denver. A letter writer to the *Denver Times* asserted that there was "no shade in the vicinity," and "the water of the lakes is foul." Nevertheless, the city began buying land in 1906. Some historians have wondered if the story of farmer Thomas M. Sloan digging a well one day in 1866 and waking the following day to find a lake was an urban legend. However, Highlands was dotted with artesian wells; groundwater was under positive pressure to flow when tapped. Cooper's Lake, formerly divided from Sloan's by a strip of land, was combined with Sloan's Lake in the 1930s. (Above, *DMF*; below, DPL, X-27726.)

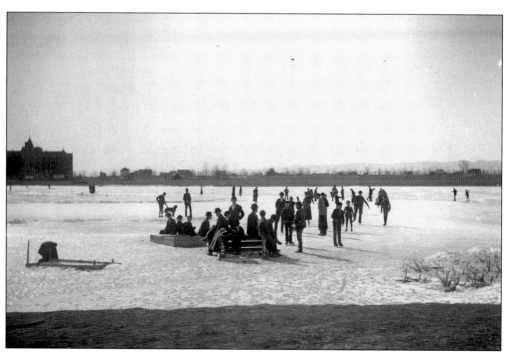

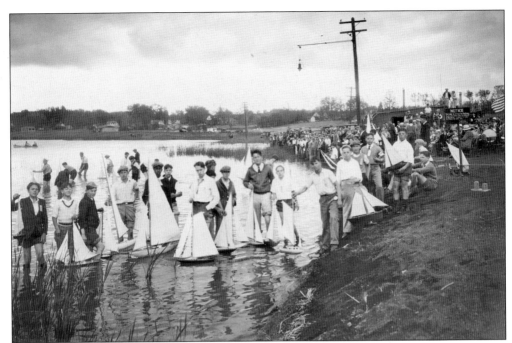

SPRING REGATTA, C. 1935. With 176 acres of water, Sloan's Lake has long been a favorite area for boaters. In the 1930s, nearby Lake Junior High School staged an annual regatta for boats built by boys in woodshop class. When powerboats became trendy after World War II, the lake became a popular site for waterskiing. Recently, Sloan's Lake has hosted the annual Colorado Dragon Boat Festival. (DPL, X-27730.)

TRAP CLUB, 1923. The private Denver Municipal Trap Club shot clay pigeons for 47 years, until 1970, on the southwest corner of Sloan's Lake; the club was partly supported by dredging spent buckshot (which contained lead, antimony, and arsenic) from the lake. Visiting skeet shooters included Roy Rogers, Jack Dempsey, and Bing Crosby. The city declared Sloan's the "most polluted lake in the Denver park system" in 1975. (DMF.)

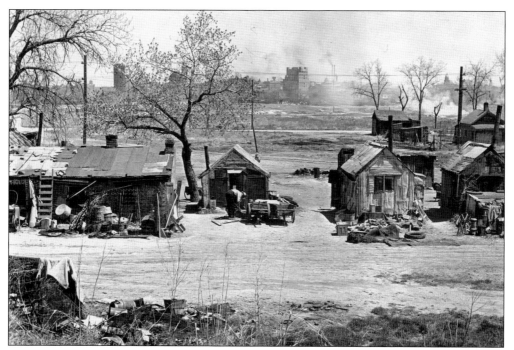

SHANTYTOWN, C. 1933. The dispossessed lived along the South Platte River floodplain long before this Depression-era photograph was taken near West Nineteenth Avenue and Clay Street. Residents had skyline views, an apparently ideal amenity for a very different kind of park—a ballpark—that was built here after World War II. (DPL, Z-2735.)

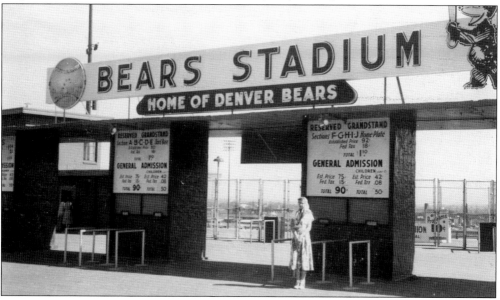

BEARS STADIUM, C. 1958. In 1948, the Denver Bears Baseball Stadium replaced the shantytown in the previous image. With roots dating to 1885, after Depression-era finances put an end to games in 1933, the minor-league Bears reemerged in 1947. The stadium's designer took advantage of the sloping land, building the seating into the hillside. This entrance was at the top of the stadium, facing west. (CRM.)

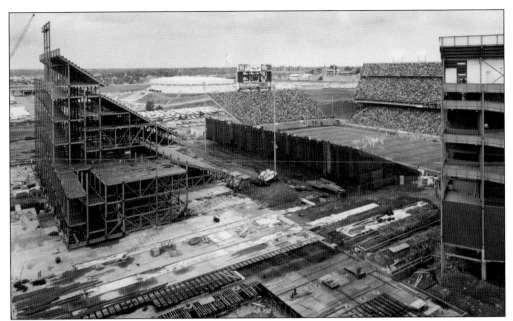

MILE HIGH STADIUM, 1976. In 1959, Denver was awarded an American Football League franchise—the Denver Broncos. Bears Stadium was enlarged for football. By 1976, ticket demand was so great that the original eastern stands were replaced by moveable stands (shown under construction) that could be pushed back for baseball season and forward for football. (Thomas J. Noel Collection, ©1988 Glenn Cuerden.)

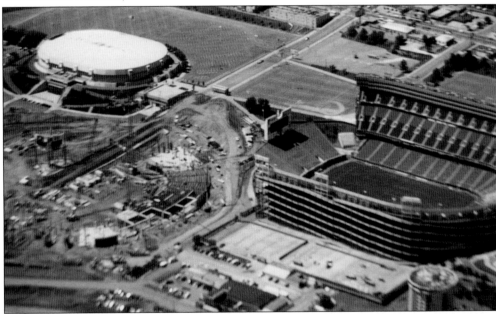

OLD AND NEW, 1999. By the 1990s, the Broncos decided that Mile High Stadium needed to be replaced. In this aerial view, a new stadium is under construction (left) near the old one. The east stands are in permanent football mode; the major-league Colorado Rockies baseball team was playing at Coors Field by this time. At upper left is McNichols Arena, which was demolished shortly after this picture was taken. (Jim McNally.)

Seven

SUMMERTIME RESORTS

Operating a summer resort in a city with only four months of reliably warm weather per year can be a dubious proposition, as northwest Denver amusement park operators learned. Over time, two parks have survived: Elitch Gardens and Lakeside. Lakeside is actually just outside of Denver, in the "town" of Lakeside, which was founded so liquor could be served. In 1994, Elitch Gardens was relocated to an area nearer to downtown, but for most of its history, it was associated with northwest Denver.

Manhattan Beach, on the northwest shore of Sloan's Lake, opened in 1890 as "Sloan's Lake Resort," the dream of German immigrant Adam Graff. With additional partners, it reopened in 1891 as Manhattan Beach. It continued to operate, with ownership and management changes, through 1908. That year, a fire destroyed most of the buildings; new investors reopened it in 1909 as Luna Park, but it only lasted a few seasons.

Elitch Gardens, owned by John and Mary Elitch, also opened in 1890. They installed a zoo, a theater, and other attractions in an apple orchard. John soon died, but Mary continued to operate the park through a second marriage to Thomas D. Long, and a second widowhood, until 1916, when financial difficulties forced her to sell it to Denver businessman John Kernan Mullen. His bankers were pessimistic about the purchase, so he resold it to John Mulvihill, whose family—through his daughter's marriage to Arnold B. Gurtler—owned Elitch Gardens until 1996.

Lakeside opened in 1908, and in early years it bore the additional moniker "The White City," echoing the 1893 Chicago World's Fair. Unlike the other two parks, Lakeside was conceived as a whole composition—Edwin H. Moorman designed the major structures and created the original layout along World's Fair lines. Lakeside, once owned by a syndicate of Denver businessmen headed by brewer Adolph Zang, went through a series of ownership changes until 1933, when it was taken over by Benjamin Krasner; his daughter Rhoda Krasner has owned and operated it since his death.

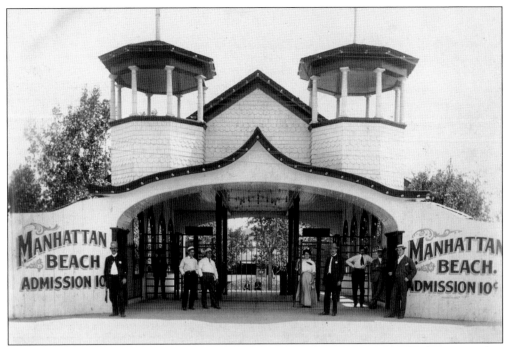

MANHATTAN BEACH GATE, 1905. In his 1901 *History of Denver*, Jerome Smiley wrote that " 'Manhattan Beach' strains a point to be entitled to its name," although he admitted that the park's summer theatricals might allow a kinship to its namesake. In 1904, new owners had most of the buildings painted white for architectural uniformity. (DPL, X-19530.)

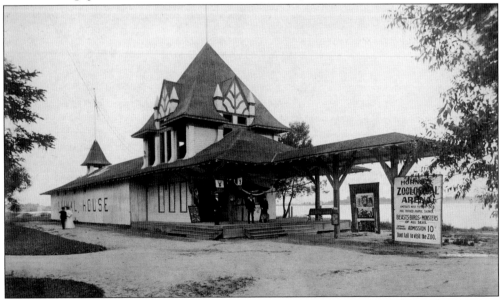

ANIMAL HOUSE, 1905. Tragedy struck Manhattan Beach in its first season. The *Rocky Mountain News* headline screamed "TERRORIZED. Roger, the Big Elephant at Manhattan Beach Takes Human Life. Six-Year-Old George W. Eaton Stamped Out of Existence." Roger had become frightened by a passenger balloon; he was euthanized after the incident. This building replaced an earlier menagerie that had been Roger's home. (DPL, X-19523.)

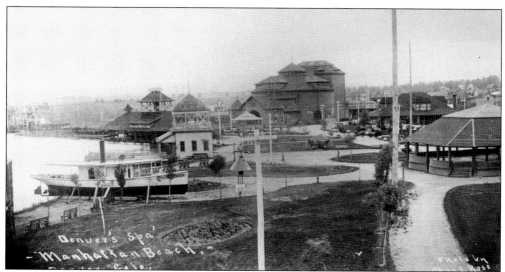

MANHATTAN BEACH PANORAMA, C. 1892. A large, round theater (center) dominated Manhattan Beach for most of its existence. Other features of the park's first years included a bowling alley, a restaurant, a camera obscura, a pier with a bandstand, a boathouse, and an animal house. Supposedly catering to the "better classes," management did not allow liquor. (DPL, X-29818.)

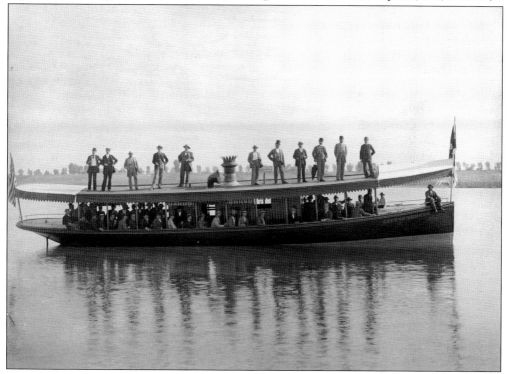

CITY OF DENVER, 1902. In 1892, the park added a former Mississippi River coal barge to its fleet of pleasure boats. With the ability to hold 150 passengers, it sailed on Sloan's Lake until 1905, when it sank. The boat's cost undoubtedly contributed to the park's 1892 foreclosure by Capt. William D. Bethel, who assumed ownership. In 1902, the boat was renovated (compare this image with the boat as shown in the previous photograph). (DPL, X-27720.)

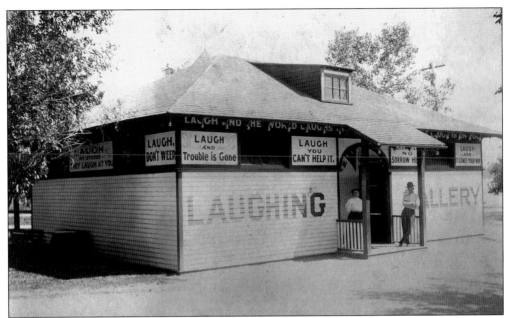

LAUGHING GALLERY, 1905. Visual distortion animated the Laughing Gallery, "where numerous mirrors of various shapes reflect the visitors in most grotesque characters," according to the *Rocky Mountain News*. Many new features were added to Manhattan Beach in 1905, including a roller-skating rink and new rowboats of "the safest style" (which did not keep three people from drowning in 1906). (DPL, X-19529.)

ELITCH LONG OPERA COMPANY, 1901. Mary Elitch Long temporarily took over management of Manhattan Beach in 1901. For the theater, which had a much larger capacity (2,000) than her Elitch Gardens Theatre, she assembled a light opera company. It was lightly patronized (although it was a "high class audience," said the *Denver Times*), and Joseph Heilbroun took over the park's management later that year. (DPL, Rh-5863.)

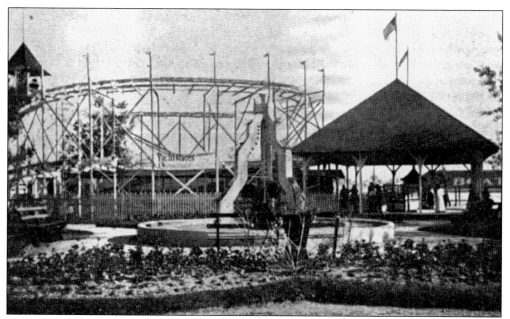

LUNA PARK, 1910. Albert Lewin, Lakeside's former manager, headed an investment group that took over Manhattan Beach after the 1908 fire, renaming it "Luna Park." Lewin added a roller coaster (the Circle Dip, above) and an over-the-water dance pavilion, and remodeled a building for a "cozy" theater to replace the destroyed one, but he could not compete with Lakeside and Elitch Gardens. (DMF.)

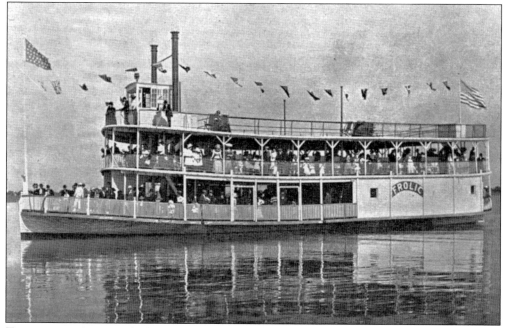

FROLIC, 1910. A Denver-built steamboat was a major Luna Park feature. The *Rocky Mountain News* and *Denver Times* sponsored a naming contest open only to children. The winning name, *Frolic*, seems oddly ill-suited to such a bulky vessel. With a 500-passenger capacity and a dance floor, the steamboat sailed Sloan's Lake for just a few years before Luna Park closed for good in 1913. (DMF.)

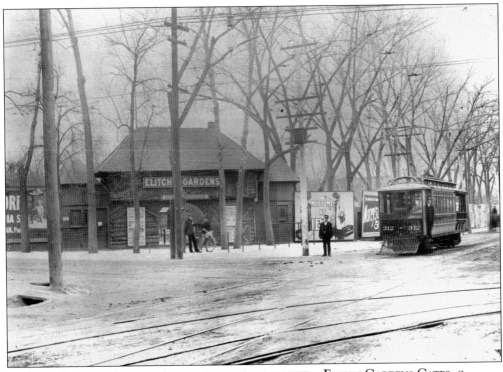

ELITCH GARDENS GATES, C. 1900 (ABOVE) AND 1911 (LEFT). In 1888, John and Mary Elitch bought the Chilcott farm at West Thirty-eighth Avenue and Tennyson Street. For their new venture, they had a rustic gate built, designed to be in keeping with the country atmosphere they were cultivating. It was ceremoniously thrown open by Denver mayor Wolfe Londoner on opening day, May 1, 1890. Other grand opening guests included Phineas Taylor Barnum and newspaperman/poet Eugene Field. In 1912, Mary Elitch built a new, neoclassical gate ("of White House aspect," said the *Denver Times*) that greeted visitors for more than 40 years—and which acquired neon trimmings in the 1930s. It was replaced in 1958, when West Thirty-eighth Avenue was widened, by a fiberglass-and-neon parabolic arch. (Above, Ellis McFadden; below, *DMF*.)

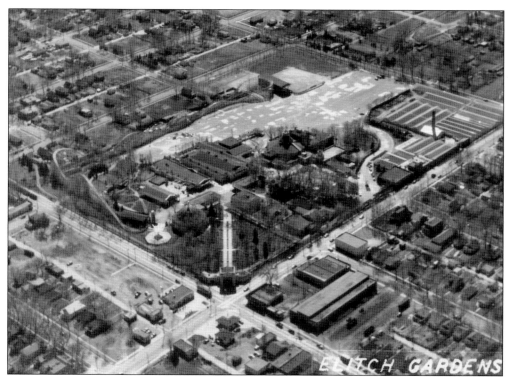

ELITCH AERIAL, C. 1941. Greenhouses and a baseball diamond dominated the park's western end (right). The greenhouses not only provided flowers for the park's gardens, they also sold carnations wholesale. The Wildcat roller coaster wrapped around the southern and eastern sides (left), while the theater dominated the center—as it does today, amidst a mixed-use redevelopment of the park. (Author's collection.)

MARY ELITCH AND SAM, C. 1902. A big draw in early days was the Elitch Zoological Garden—the two black bears were named Dewey and Uncle Sam. Other animals in the zoo included ostriches, deer, antelope, camels, monkeys, lions, and an albino buffalo. The zoo was phased out and the bear pit filled in around the time of World War I. (Author's collection.)

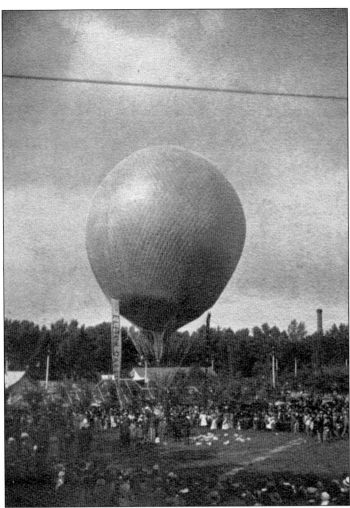

IVY BALDWIN'S BALLOON, c. 1897. Balloon ascensions, in which a professional aerialist would float to the clouds while tied to the ground, were common in early amusement parks. "Professor" Ivy Baldwin was the best-known balloonist in Denver, working at Elitch's for several years and making thousands of ascensions—often followed by parachute jumps. This form of entertainment faded away by about 1915. (Author's collection.)

SCHOOL PICNIC, 1914. Mary Elitch combined her two loves, theater and children, when she created the Elitch School of Theatre and Dance. Lessons were free and children were taught various performing arts; Elitch Theatre star Maude Fealy eventually supervised the school. The park also hosted class picnics, such as this one for the Miss Wolcott School, a private girls' academy—staging Shakespeare was part of the fun. (DMF.)

ELITCH FLORA, C. 1910 (ABOVE) AND 1946 (BELOW). "Gardens" in the park's name defined the essence of Elitch's and differentiated it from the two lake-oriented parks in the Denver area. Mary Elitch began the tradition of supplementing the wonderfully shady atmosphere (reflecting the park's beginnings as a fruit orchard) with potted ferns, hanging baskets, and colorful annuals. When John Mulvihill took over, he built greenhouses and expanded Elitch's flowerbeds. His son-in-law and successor, Arnold Gurtler, hired George Gero as head gardener to oversee 50,000 plants each year. One display included a large floral clock with a calendar. Another spelled out the park's motto, "Not to See Elitch's is Not to See Denver." (Above, author's collection; below, DPL, Z-348.)

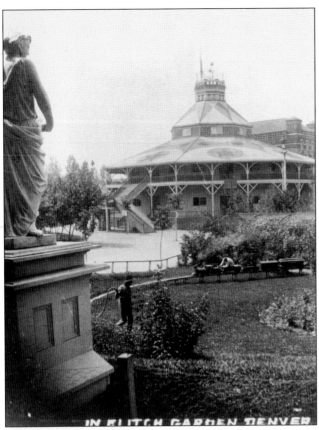

ELITCH THEATRE, C. 1892 (LEFT) AND C. 1900 (BELOW). John and Mary Elitch were involved in theater before arriving in Denver; in fact, John died the winter after Elitch Gardens opened while on tour with a vaudeville troupe. As a memorial to John and as a statement of faith in her own ability to run the gardens, Mary completed the Elitch Theatre in 1891 (left). It initially featured traveling vaudeville acts, but in 1897, Mary upgraded the offering, creating a theatrical stock company to perform legitimate drama—the first season featured James O'Neill, whose son was the playwright Eugene O'Neill. It was immensely successful and soon attracted large crowds (below). Before the final season, in 1987, it was the nation's oldest summer stock theater company. (Left, Ellis McFadden; below, author's collection.)

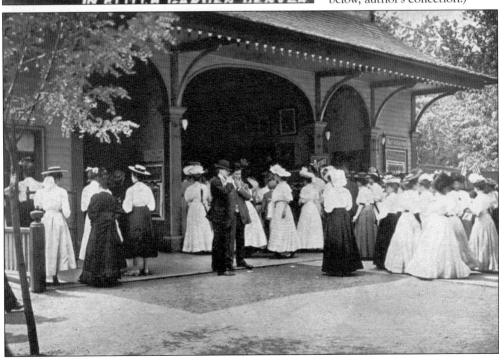

ELITCH THEATRE, 1923 (ABOVE) AND C. 1900 (BELOW). Mary Elitch remodeled the theatre in 1902, enlarging its capacity and enclosing the second-floor walkway; these changes gave the building the appearance it retains today (above). The famous curtain (below) depicted Anne Hathaway's cottage; the image of the house of the wife of Shakespeare telegraphed the message that only classy drama would be performed. Film director Cecil B. DeMille, who performed in the 1905 season, remained a friend of the theater long after he moved to Hollywood, referring to the Elitch Theatre as "one of the cradles of American drama." That sentiment reflects the esteem many held for Mary Elitch's creation. (Above, DPL, X-24651; below, author's collection.)

THEATER LOBBY, C. 1928 (ABOVE), AND ADVERTISEMENT, 1914 (BELOW). Patrons passed through a lobby lined with portraits of famous actors who had trod the Elitch boards. During Mary Elitch's tenure, these included Sarah Bernhardt, Harold Lloyd, Douglas Fairbanks, Antoinette Perry, Spring Byington, and Tyrone Power. Some, like Bernhardt, were already famous; others became so later. During the Mulvihill/Gurtler years, Elitch alumni included Beulah Bondi, Sylvia Sidney, Grace Kelly, Patricia Neal, Raymond Burr, Edward G. Robinson, Gloria Swanson, Cesar Romero, Morey Amsterdam, William Shatner, Mickey Rooney, Lynn Redgrave, Nancy Walker, and Cloris Leachman, among others. *Denver Post* heiress Helen G. Bonfils was active with the Elitch Theatre in both acting and producing roles. As the advertisement below shows, theater was one of many entertainment options at Elitch Gardens. (Both, author's collection.)

TROCADERO BALLROOM, C. 1935. "The Summer Home of America's Biggest Bands," the Trocadero attracted crowds to Elitch's from its opening in 1917. Mary Elitch did not allow dancing when she controlled the park, but the second owner, John Mulvihill, knew that a ballroom would allow more effective competition with Lakeside. The "Troc" was demolished after the 1975 season, to public outcry. (Author's collection.)

OLD GRILL ROOM, 1939. Adjacent to the Trocadero, the Old Grill Room offered a place to buy cold beer, or sweets from the popular downtown restaurant Baur's. In the 1930s and 1940s, the ballroom, with its "floating" floor (resting on horsehair padding) might host 1,500 couples in an evening. The building featured arched openings on all sides to let in fresh air. (DPL, X-27384.)

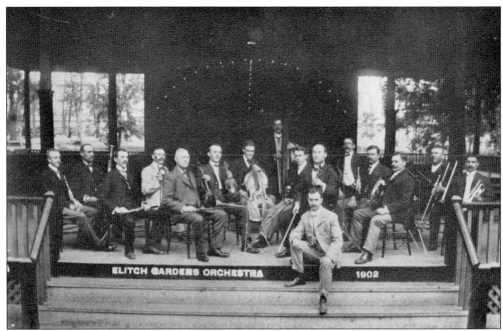

ORCHESTRA, 1902. The Elitch Gardens Orchestra, begun by conductor Raffaelo Cavallo in 1897, was Denver's first symphony orchestra, with concerts held each Friday afternoon. Horace Tureman later took over; in 1922, he became the Denver Symphony's first conductor. The orchestra's list of guest artists included Fritz Kreisler and the great Polish pianist Ignacy Paderewski. (Author's collection.)

NORTH PICNIC PAVILION, C. 1935. Picnic tables were everywhere at Elitch's—inside colorful buildings such as this one near the theater, or in open air. Generations of Denverites brought their own food into Elitch's for inexpensive outings. The "Fryer Hill" picnic area featured tables named for famous Leadville silver mines, imparting a Colorado history lesson. (Author's collection.)

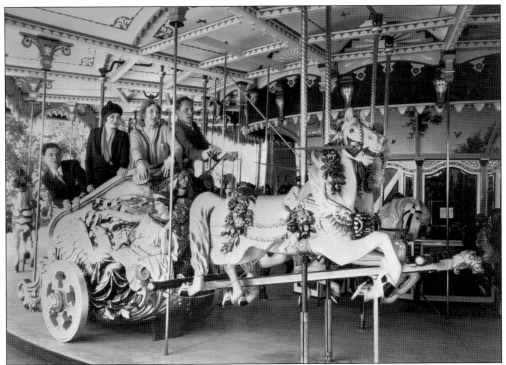

MERRY-GO-ROUND, 1928. Frederic March, the 1928 theater season's leading man, "drives" the merry-go-round's chariot. Built by the Philadelphia Toboggan Company, the 64-horse ride was commissioned in 1926 and installed in 1928. The domed building that originally housed it still stands; the ride itself was moved to the new Elitch Gardens. Elitch's preferred the term "merry-go-round" to carousel. (DPL, X-27387.)

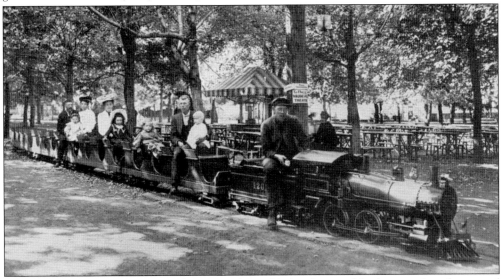

MINIATURE TRAIN, C. 1905. Frank H. Root (seated behind engine) built, owned, and operated the train at Elitch's from 1893 until his death in 1935. The Highlands native attended Ashland School and built his first miniature locomotive as a teenager. He turned his hobby into a livelihood and spent years giving rides to children. (Author's collection.)

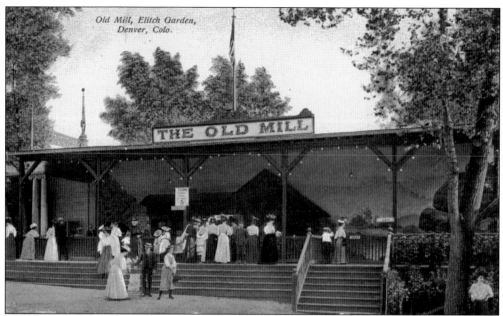

OLD MILL, C. 1905. When this tunnel of love opened in 1904, it was described in the Denver *Republican* as an "underground river" upon which riders floated past painted scenes of "heaven and hell, under the sea, fairyland, Brownie land, Japan, the South," and "over-towering mountains." It was the site of Elitch's worst tragedy—a 1944 flash fire in which two employees and four guests died. (Author's collection.)

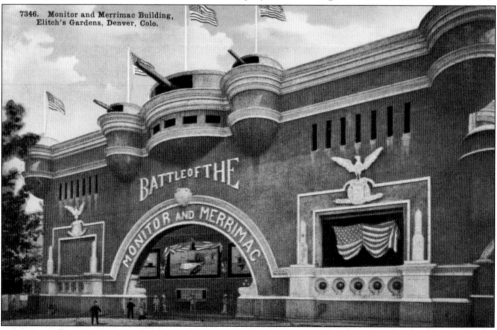

BATTLE OF THE MONITOR AND MERRIMAC, 1910. Costing $250,000, this feature presented a reenactment of the famous Civil War naval battle. Despite its cost, the building was poorly constructed and collapsed almost immediately after it opened in 1910. Mary Elitch had it rebuilt with a steel frame, but it burned down in 1914; the "Battle" undoubtedly contributed to her financial difficulties. (Author's collection.)

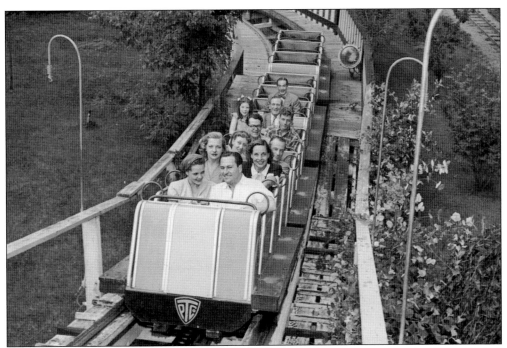

WILDCAT, C. 1948 (ABOVE) AND C. 1943 (BELOW). Elitch's first roller coaster was the "Figure Eight," installed in 1904. The Wildcat opened in 1935 and operated until the park closed in 1994. Of "camelback" design, with plenty of up-and-down motion but not much in the way of hard turns, it was overshadowed by Mister Twister in later years, and was nearly demolished for the Splinter log flume ride in 1977. Public outcry saved it, and the Splinter was redesigned to intertwine with the Wildcat (which itself intertwined with Mister Twister). The respite was brief, however; when the park moved, there was no effort to replicate Wildcat in the new location, as there was with Mister Twister. (Above, DPL, X-27388; below, author's collection.)

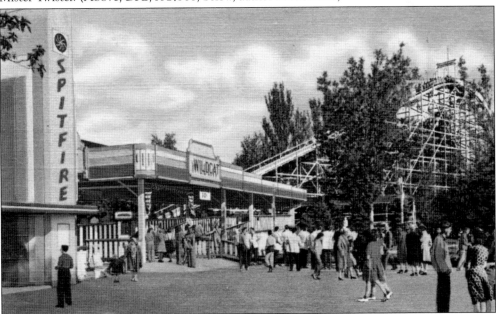

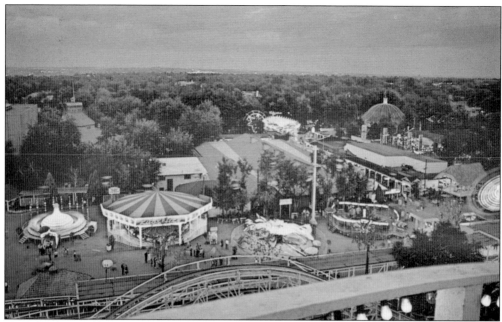

MISTER TWISTER VIEW, C. 1969. Everyone's favorite from its opening in 1965, this roller coaster was made with 262,505 board feet of lumber and 2,648 gallons of white paint. Its designer, John Allen, of the Philadelphia Toboggan Company, explained its appeal to the *Denver Post:* "if we can plan it so a fellow's girl slams into his arms as they go around a curve . . . we've come up with a perfect design." (Author's collection.)

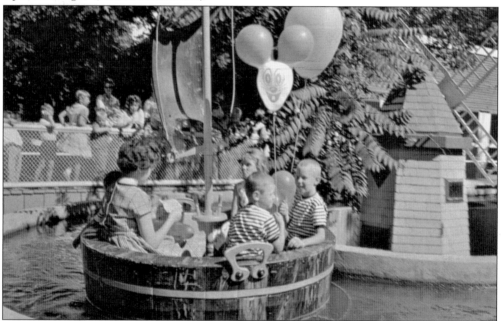

KIDDIELAND, C. 1966. Although the park had always catered to children, the idea for a separate children's area arose around 1946 with the advent of the baby boom. Kiddieland began with four rides and later had as many as twelve; these included a miniature roller coaster, boats that children steered along a course, an auto turnpike, and a dune buggy ride. (Author's collection.)

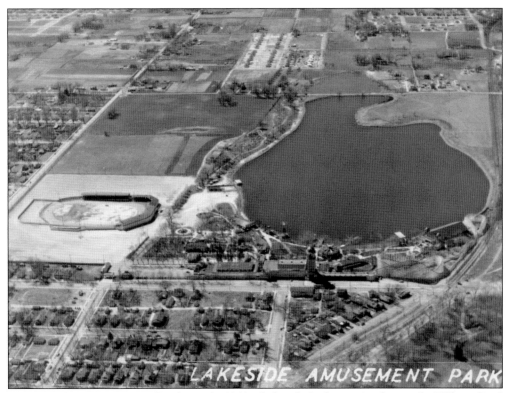

LAKESIDE AERIAL, C. 1941. By the early 1940s, Lakeside had jettisoned its early "White City" moniker and become more dominated by thrill rides than when it opened in 1908. The Edward Vettel–designed Cyclone roller coaster, which wrapped around the northeast corner of the park (lower right), premiered in 1940, while the southern end (left) of the park featured a race track that was occasionally used for bullfights. (Author's collection.)

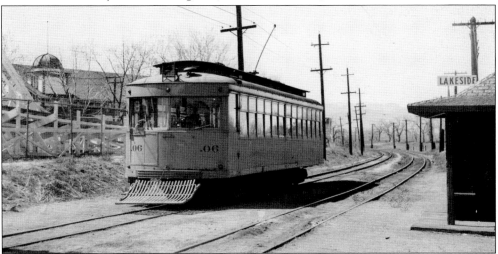

INTERURBAN STOP, C. 1920. This was the Lakeside stop on a Denver Tramway Company subsidiary's interurban rail line to Golden. Though the park's environs were largely rural in its early years, advertisements assured potential customers that Lakeside was "20 Minutes' Ride From [the] Center of the City." (CRM.)

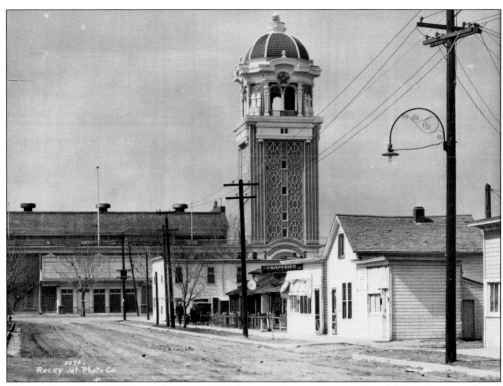

CASINO TOWER, C. 1920 (ABOVE) AND C. 1910 (BELOW). In an interview, Arnold Gurtler remembered that when it opened, "Lakeside kicked the slats right out from Elitch's." Lakeside had many attractions that Elitch's lacked at the time, including ballroom dancing. But perhaps most importantly, Lakeside had architectural magnificence in the form of brilliantly illuminated Beaux Arts buildings by Edwin H. Moorman, particularly the 150-foot Casino Tower (also known as the "Tower of Jewels") and attached Casino Building, marking the park's main entrance on Sheridan Boulevard at West Forty-sixth Avenue. The building included a German-style rathskeller (serving Zang Beer) on the ground level, "The Porch Café," a roof garden, and a theater. (Above, DPL, X-27615; below, author's collection.)

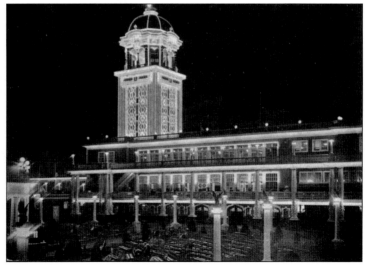

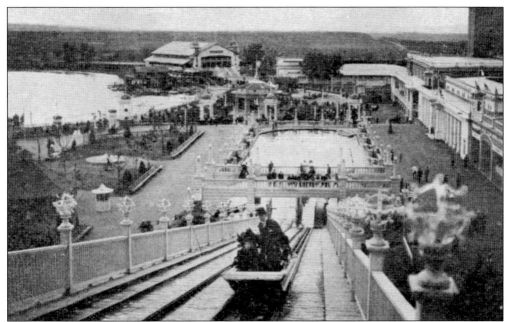

LAKESIDE ATTRACTIONS, 1911. Decades before the popularity of log flume rides, Lakeside featured a precursor, the "Shoot-the-Chutes" (above). Presumably, the formally dressed riders did not get too wet, although the *Denver Republican* referred to it as the "big splash." The ballroom (below) anchored the park's northwest corner. Other major early attractions included a roller-skating rink, a natatorium (indoor swimming pool), a boathouse with pier and boats, and a large concert plaza. Lakeside, according to its publicity staff (as parroted by the *Republican*), "will be large enough for all classes, but at the same time the park will be so carefully conducted that the most conservative pleasure-seeker will find nothing offensive and no undesirable element will be catered to." Undoubtedly, this was meant to reassure skeptical temperance advocates. (Above, *DMF*; below, author's collection.)

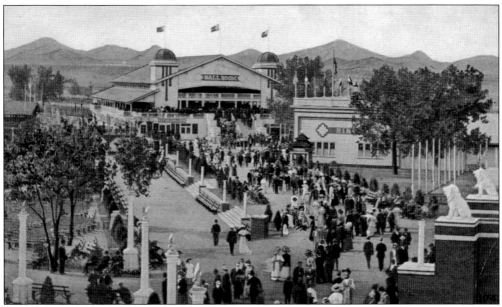

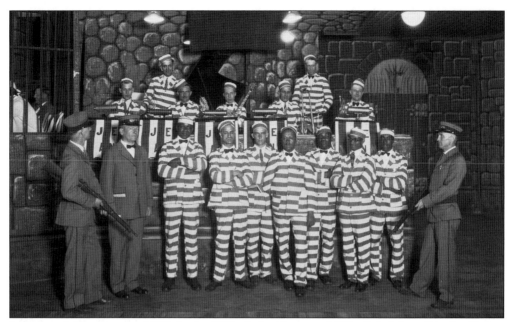

JOE MANN'S ORCHESTRA, 1926. In the 1920s, Lakeside opened "The Jail Cabaret" in the Casino Building, with the orchestra dressed accordingly. According to historian Marjorie Hornbein, "the musicians, dressed as 'jailbirds,' were confined to the 'bullpen'; to complete the prison atmosphere, patrons were served on paper plates and drank from tin cups." African Americans were not routinely welcome as park guests, and in 1940 were banned completely. (DPL, X-27619.)

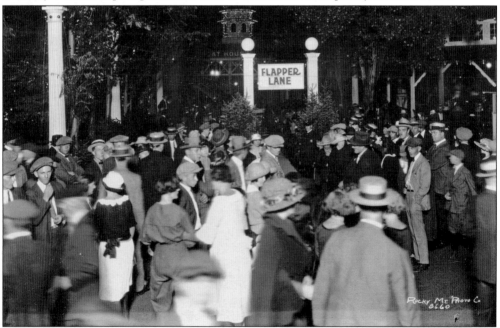

FLAPPER LANE, 1922. Capitalizing on the national "bobbed hair" craze, Lakeside sponsored a "flapper" beauty contest. With a first prize of $25 in gold, it was open to "any modern miss of good deportment and good reputation." Girls were judged by men who showed "ability in the art of discrimination in matters of 1922 feminine pulchritude," according to the *Rocky Mountain News*. (DPL, X-27626.)

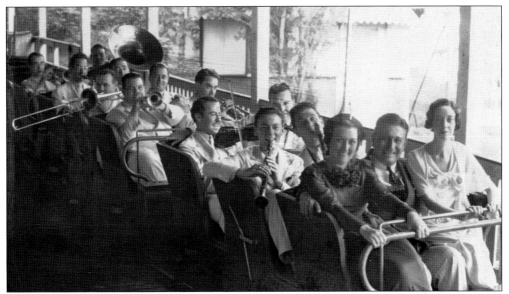

LAKESIDE ORCHESTRAS, 1934 (ABOVE) AND 1937 (BELOW). Tom Gerun, in the front seat of the Derby roller coaster with his orchestra behind him (above), was typical of musical acts Lakeside booked for its El Patio ballroom, as was Kay Kyser, the "Ol' Professor of Swing" (below). In contrast to the dance-oriented bands Elitch's preferred, the music at El Patio (and the Casino Theatre) was hotter and jazzier. El Patio was renamed "Moonlight Gardens" in the 1950s, and became a discotheque in the late 1960s. It was demolished in 1974, a year after the Jefferson County district attorney attempted to have Lakeside shut down for building code violations. Old buildings like the ballroom and Fun House were less costly to demolish than renovate. (Above, DPL, X-27599; below, DPL, X-27613.)

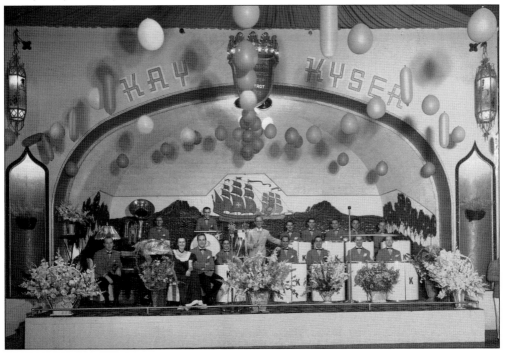

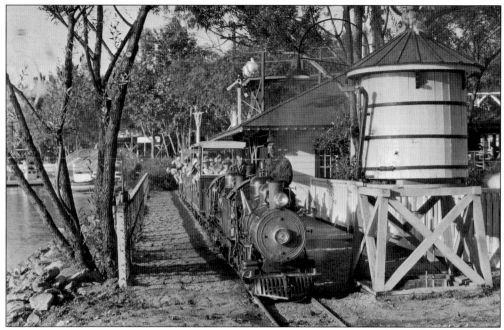

LAKE SHORE RAILROAD, C. 1930 (ABOVE) AND C. 1950 (BELOW). After the roller coasters, the most popular ride for much of Lakeside's history was the miniature train, which followed a one-and-a-half-mile-long route around the lake—supposedly, the longest miniature train ride in the country. The two steam locomotives (*Whistling Tom* and *Puffing Billie*; one is visible above), originally built for the 1904 St. Louis World's Fair, were painted in Denver & Rio Grande Western railroad colors. In 1950, Lakeside introduced the streamlined, stainless steel California Zephyr (below), built by Denver Machine Shops and Zimmerman Ornamental Iron Works. The diesel-powered Zephyr featured a real air horn and air brakes and ran on an alternating schedule with the older locomotives. (Above, DPL, X-27433; below, author's collection.)

DERBY ROLLER COASTER, 1914. When it opened, Lakeside featured the Velvet Coaster, which was soon replaced with the more thrilling Derby. In 1940, the Cyclone replaced the Derby. As with many coasters, there were mishaps on the Cyclone, including the deaths of two airmen from Lowry Air Force Base—one in 1954 and another in 1962 (neither obeyed the rules). A steel coaster, the Wild Chipmunk, arrived in 1955. (*DMF.*)

LAKESIDE SWIMMERS, C. 1920. Around 1916, with indoor swimming available at the natatorium, Lakeside added outdoor swimming, complete with diving tower, to its attractions. Originally called "Sylvan Lake" or "West Berkeley Lake," some mapmakers redundantly referred to it as "Lakeside Lake" (page 2). After Benjamin Krasner bought the park, he renamed the body of water "Lake Rhoda" after his daughter. (DPL, X-27596.)

DISCOVER THOUSANDS OF LOCAL HISTORY BOOKS
FEATURING MILLIONS OF VINTAGE IMAGES

Arcadia Publishing, the leading local history publisher in the United States, is committed to making history accessible and meaningful through publishing books that celebrate and preserve the heritage of America's people and places.

Find more books like this at
www.arcadiapublishing.com

Search for your hometown history, your old stomping grounds, and even your favorite sports team.